Lil' Buckaroos

A TRIBUTE TO THE YOUNG COWBOY IN ALL OF US

PHOTOGRAPHY BY DAVID R. STOECKLEIN

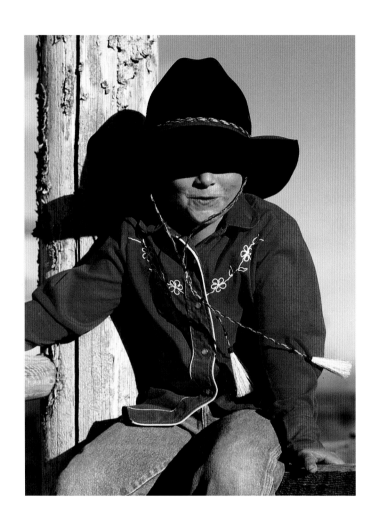 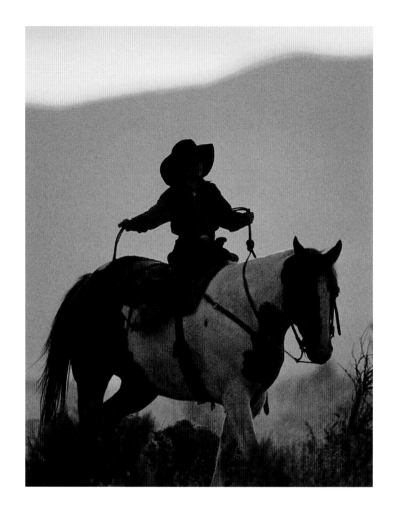

Eric Hoggan and Ginger Barrett were two of the
first Lil' Buckaroos I met. They were cousins and
they were both wonderful kids—full of life and
always looking for cowboy fun. They have both
passed away and we all miss them.

Lil' Buckaroos

A TRIBUTE TO THE YOUNG COWBOY IN ALL OF US

This book is dedicated to the spirit of all Lil' Buckaroos.

—David R. Stoecklein

STOECKLEIN PUBLISHING

Lil' Buckaroos

A TRIBUTE TO THE YOUNG COWBOY IN ALL OF US

PHOTOGRAPHY	DAVID R. STOECKLEIN
TEXT	DAVID R. STOECKLEIN
EDITOR	CARRIE JAMES
ART DIRECTION & DESIGN	T-GRAPHICS

Cover Photo - Colby Stoecklein
Back Cover Photo - Sarah Black

All images in this book are available as signed original gallery prints and for stock photography usage. Stoecklein Photography houses an extensive stock library of western, sports, and lifestyle images. Dave Stoecklein is also an assignment photographer whose clients include Canon, Kodak, Bayer, Hatteras, Marlboro, Chevrolet, Timberland, Ford, Wrangler, Pontiac, and the Cayman Islands.

Other books by Stoecklein Publishing include The Idaho Cowboy, Cowboy Gear, Don't Fence Me In, The Texas Cowboys, The Montana Cowboy, The Western Horse, Cowgirls, Spirit of the West, The California Cowboy, The Performance Horse, Cow Dogs, and The American Paint Horse.

Every year, Stoecklein Publishing also produces a line of wall calendars, prints, and cards featuring the western photography of David R. Stoecklein. For more information or to request a catalog, please contact:

Stoecklein Publishing & Photography
Tenth Street Center, Suite A1
Post Office Box 856 • Ketchum, Idaho 83340
tel 208.726.5191 fax 208.726.9752 toll-free 800.727.5191
www.stoeckleinphotography.com

Published by World Publishing Services
2135 Wilder Street • Helena, Montana 59601

Printed in China

ISBN 1-931153-21-3
Library of Congress Catalog number 2002091147

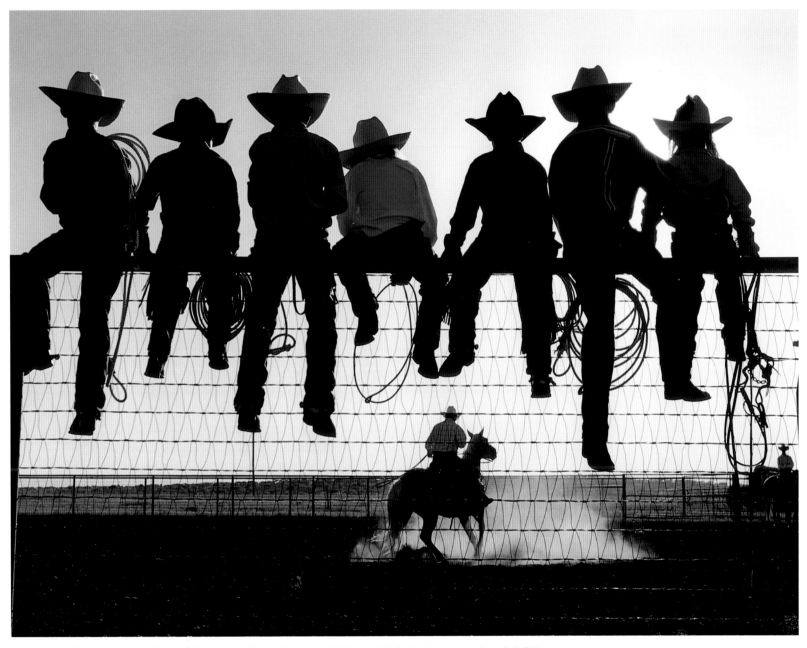

Griffin Brown, Tucker Brown, RA Brown II, Laurie Bellah, Myles Brown, Brad Bellah, and Emily McCartney learn from Jody Bellah.
R.A. Brown Ranch, Throckmorton, Texas

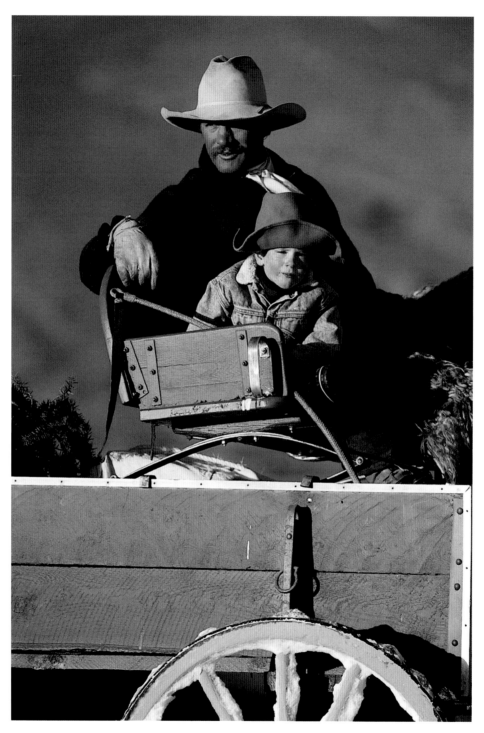

Jack Goddard and Taylor Stoecklein
Bar 13 Ranch, Mackay, Idaho

Introduction

I had so much fun with this project, going through all my old photographs of kids—the ranch kids, the kids who love horses, sheep, and cows, the kids who dream of being cowboys or cowgirls and riding the range like Mom and Dad or good old Grandpa. There are even kids like me, city kids who want to be like Hopalong Cassidy or Roy Rogers and ride a horse like Trigger and sleep under the stars.

In sorting through all the old and new photographs for this book, I found some great shots of my kids, my friends' kids, my neighbors' kids, and more. Most of all, I learned why we all take photos—to record history, to record the lives of our children and our families, to tell a story, communicate an idea, or even just to remember a time or a place. What would our world be like without these images, these simple photos that mean so much to us all?

I saw my kids again when they were so small and new to this world, struggling to get on Old Silk or watching the blacksmith work. Editing this book has taken me on a wonderful trip down "Memory Lane." I often went home after working on it and told my wife Mary about all the great photos I was finding of our sons Drew, Colby, and Taylor. They are now all too old to be lil' buckaroos and are rushing headlong into their teenage years as extreme skiers and tough guys.

This collection is about ranch life as seen through the eyes of cowboy kids. Some of these photos come from reenactments of ideas or stories and some are snapshots I took traveling around the West while working on my other books about ranch life. There is a progression here of age and maturity and skill. You will notice that some of these lil' buckaroos reappear throughout the book at different stages in life—having fun and always learning.

These are photos of the simple life that exists on a ranch. Kids entertain themselves swimming in nearby lakes or riding horses or chasing the family dog or trying to train the goat. They all like to rope and ride and they all love the horses, dogs, calves, rabbits, and pigs that are present on every ranch. There are photos of mothers and fathers teaching their kids, helping them, protecting them, and laughing with them. Family and tradition play a big part in ranch life. Kids today still use logs, boxes, fence posts, and friends to help them get up on the big horses—the same methods little kids used on ranches 100 years ago.

Horses and kids love and understand each other so well. Like adults, horses nurture their young. The biggest horses always seem to be the gentlest. Everyone always wants to have a big, gentle horse just for kids, but they aren't easy to find because nobody sells them. People pass them on to friends or grandkids—they are the most treasured, the most sought-after, the hardest to obtain. They are the ones owners brag about the most and the ones that generate the best memories. The best horses for kids come in all breeds and colors—it is the personality of the horse that counts.

I hope you enjoy this book as much as I enjoyed putting it together. I hope it brings back memories of the good old times. My thanks go out to all the kids for letting me into their lives and into their hearts.

—DRS

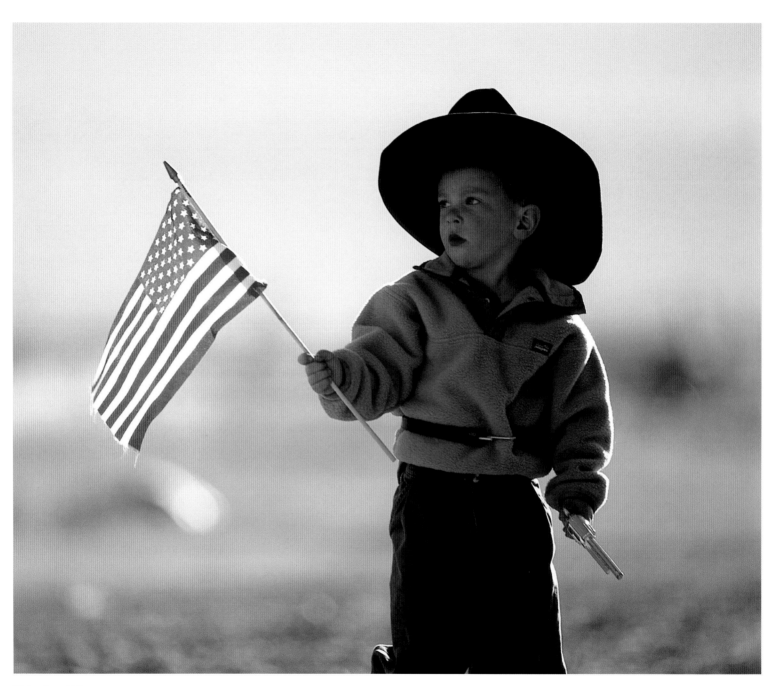

Taylor Stoecklein
Bar Horseshoe Ranch, Mackay, Idaho

For my Mom...
...who let me play cowboy
whenever I wanted.
Love, David

His heart is all adventure

He longs to ride like you,

If he could just get half a chance

He'd show you what he can do.

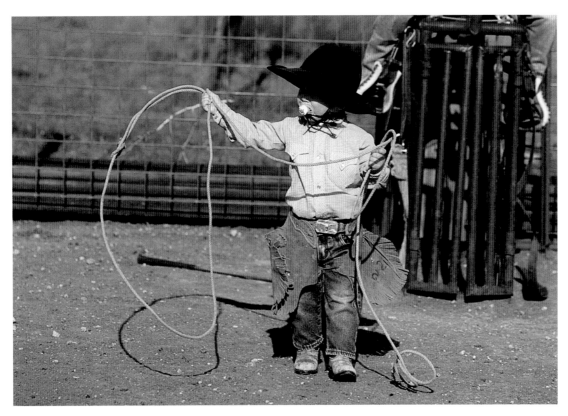

Myles Brown
R.A. Brown Ranch, Throckmorton, Texas

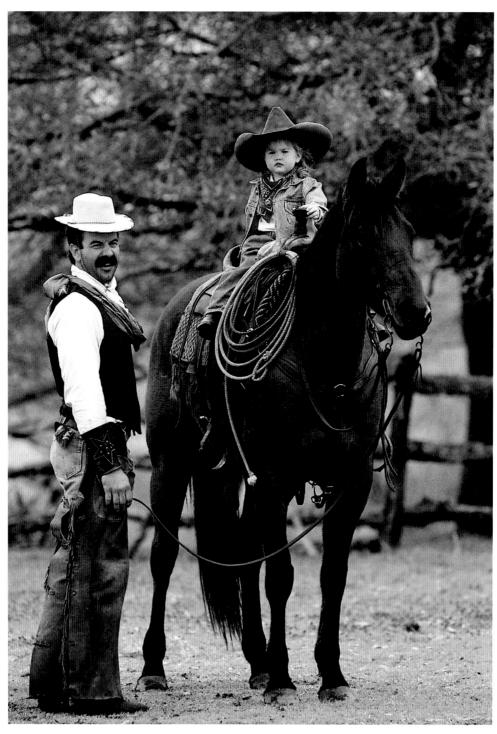

Thomas and Leslie Anne Saunders
Twin V Ranch, Weatherford, Texas

It is amazing what a rough, tough cowboy will do to make his little girl smile.

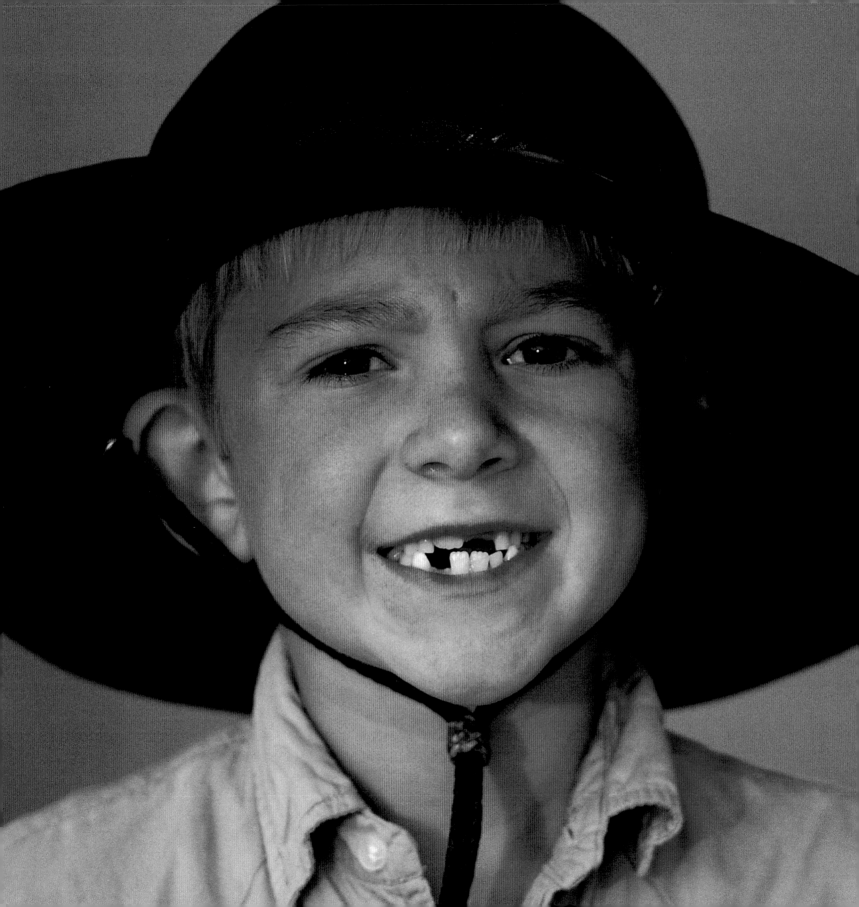

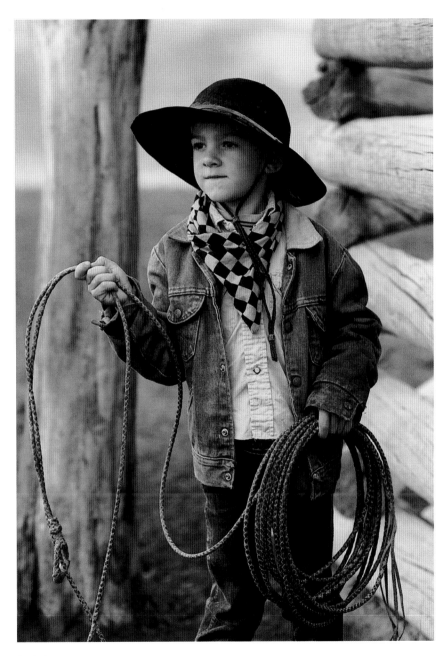

Levie Jayo
Jayo Ranch, Idaho

"All I want for Christmas..."

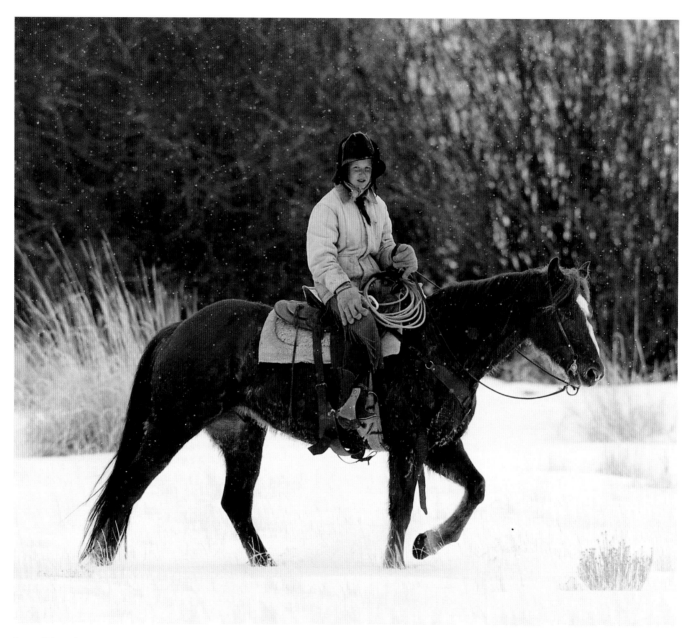

Jasper Schroeder
Dragging Y Cattle Company, Montana

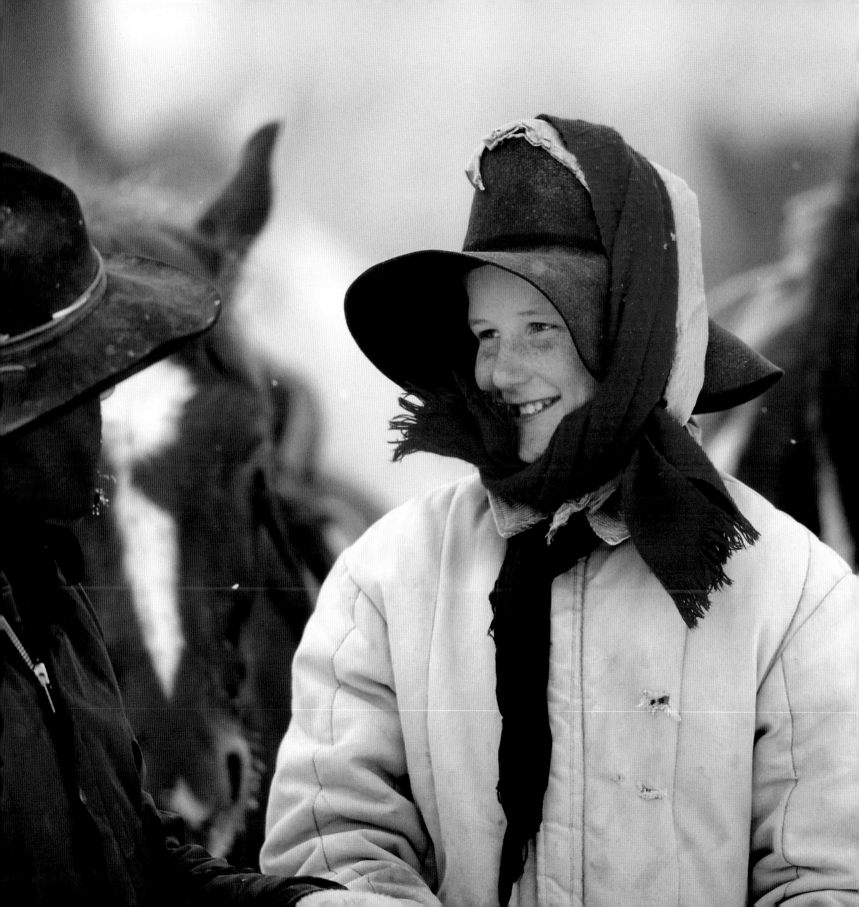

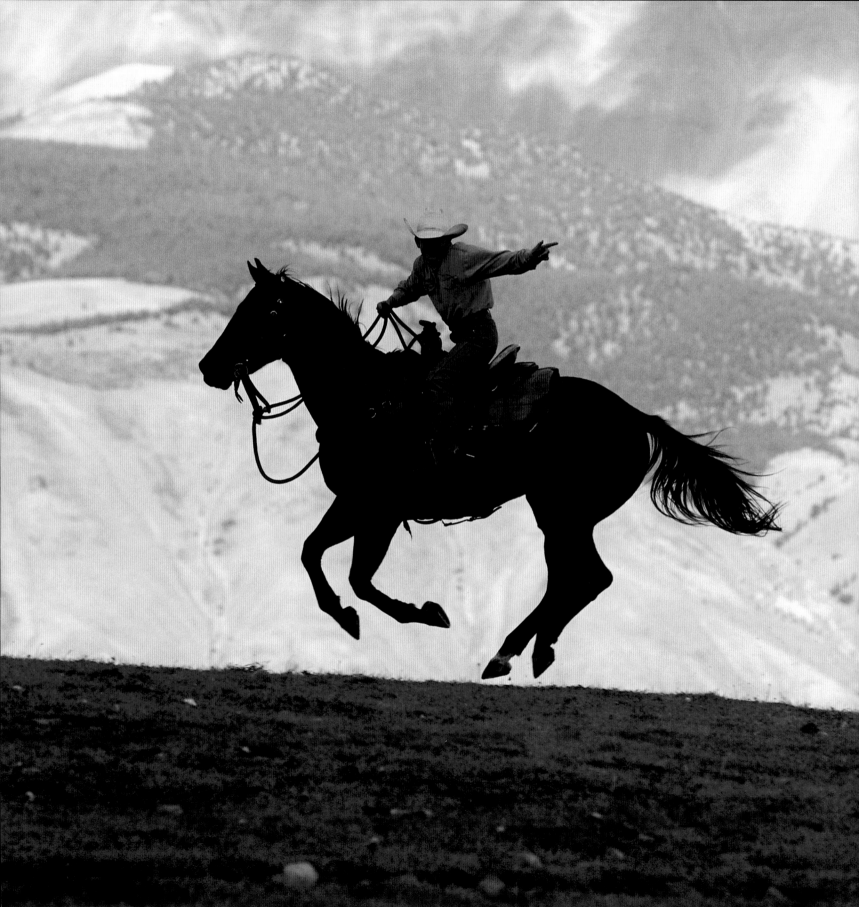

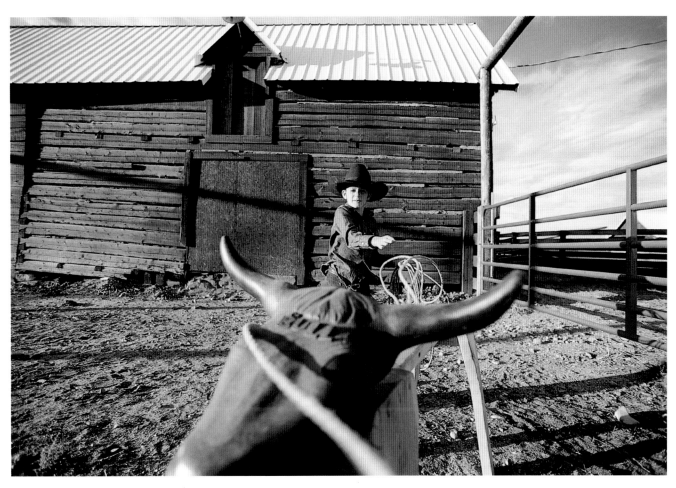

Rial Pate
Pate Ranch, Montana

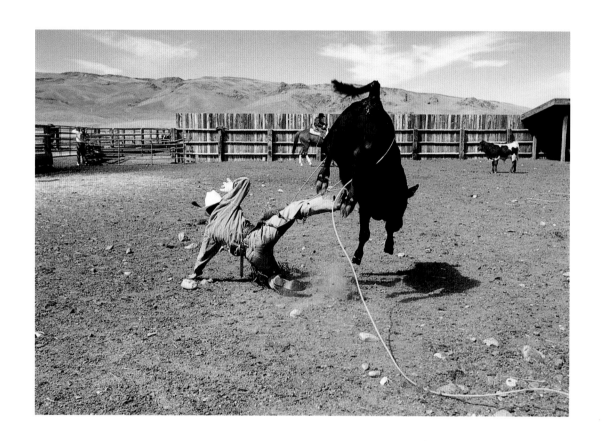

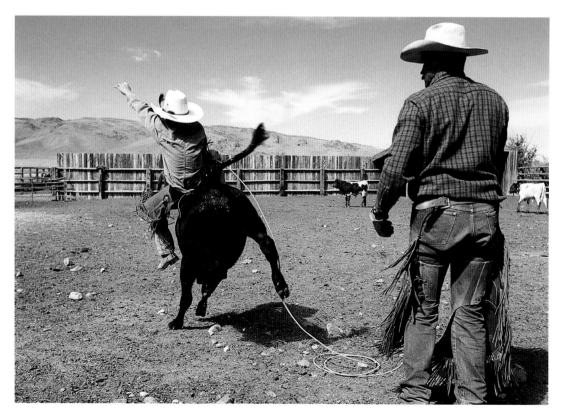

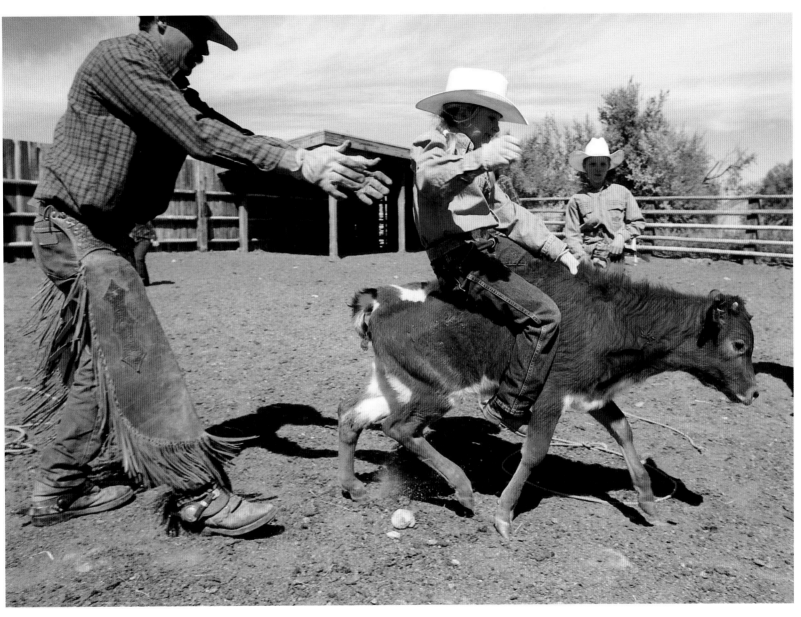

Eric Shields, Dad "Butch" and Kindee Wilson
Broken River Ranch, Idaho

...got to start somewhere...

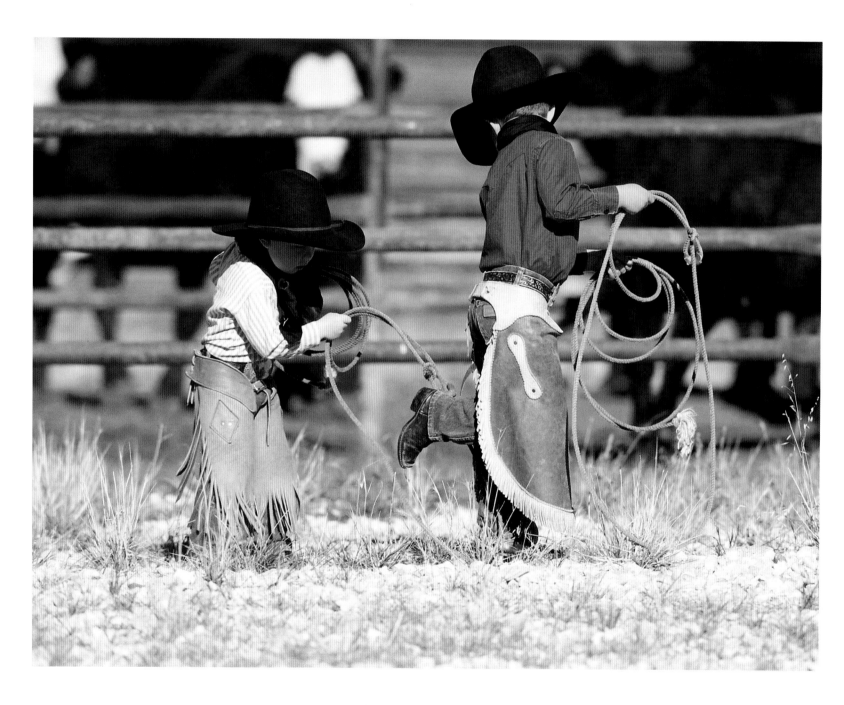

"Got ya!"

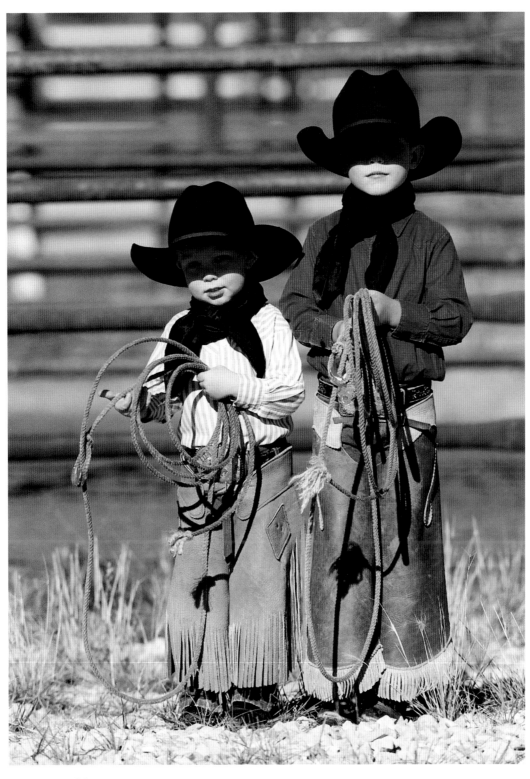

Jared and Jake Gill
Sun Light Ranch, Montana

Bath time.

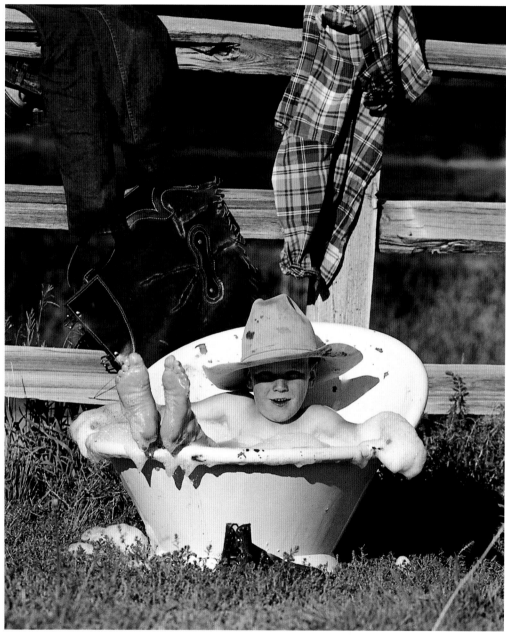

Lincoln Zollinger
Zollinger Ranch, Idaho

Drew, Taylor and Colby Stoecklein
Bar Horseshoe Ranch, Idaho

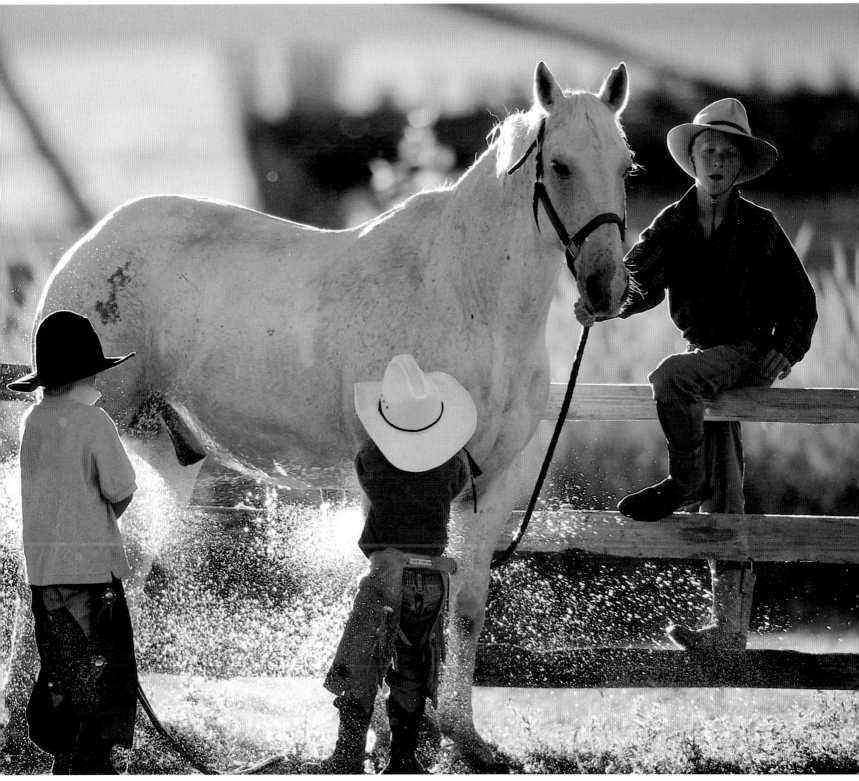

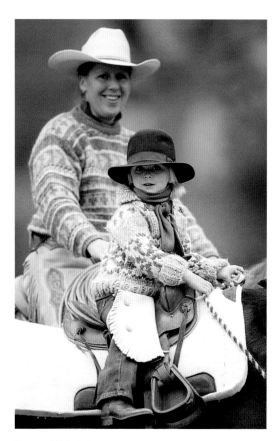

Kate and Sally Askew
Carmel Valley, California

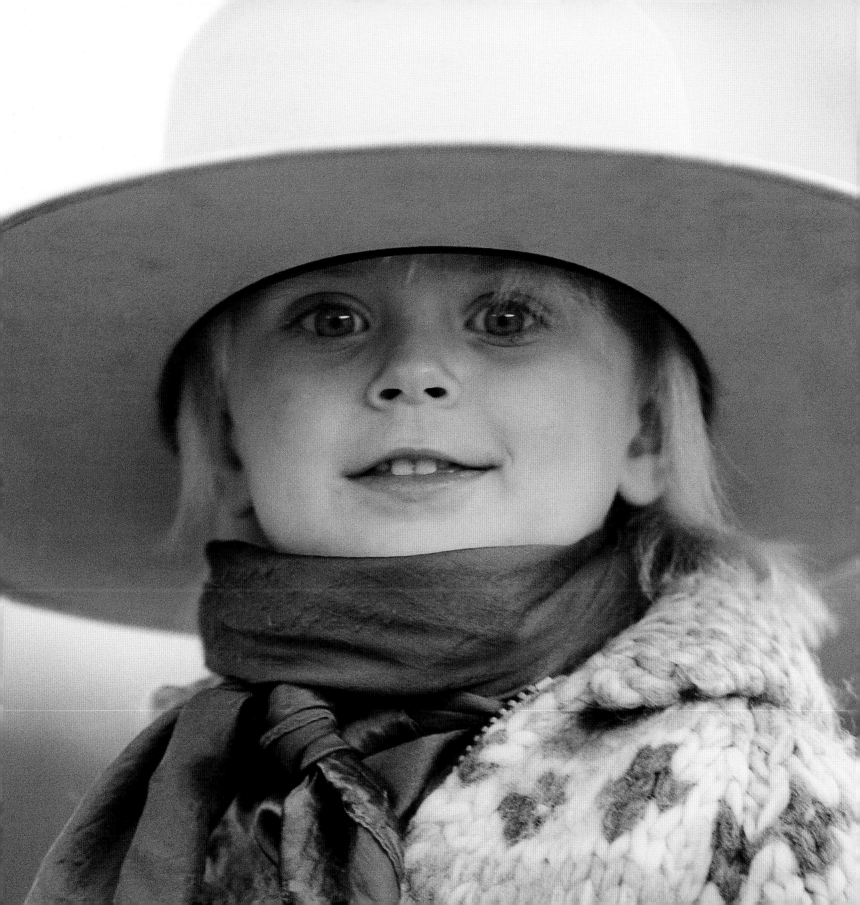

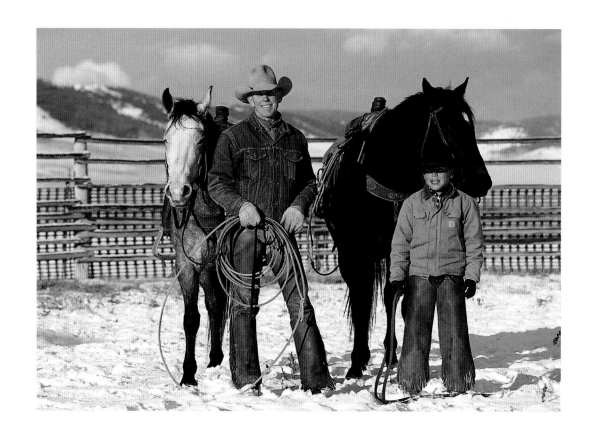

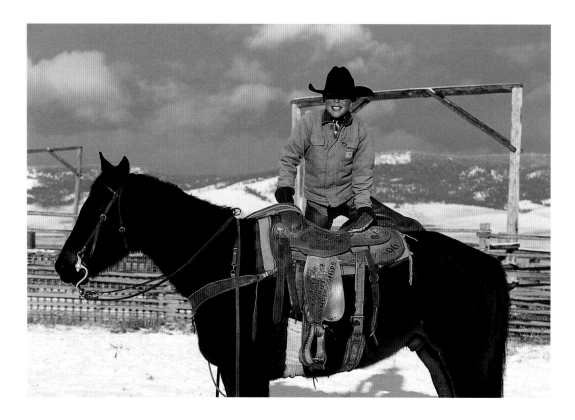

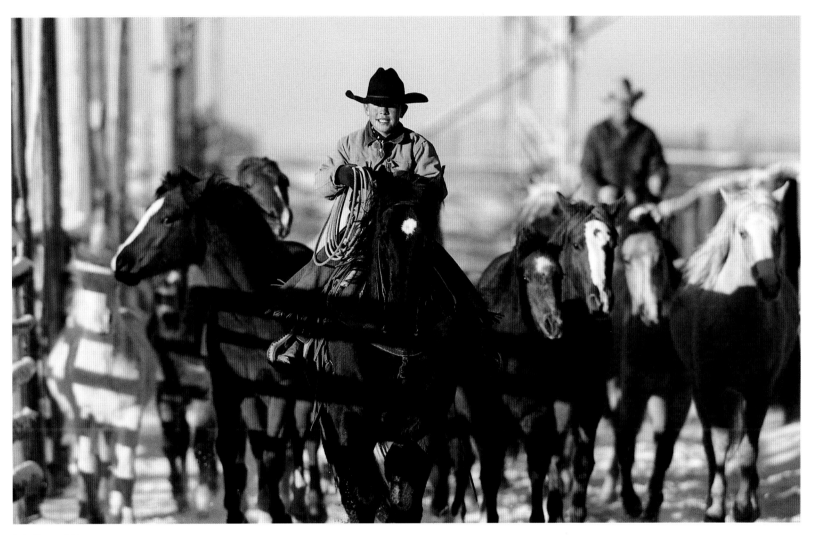

John Vermedahl
Vermedahl Ranch, Montana

So proud.

Gettin' ready.

30

RA Brown II
R.A. Brown Ranch, Texas

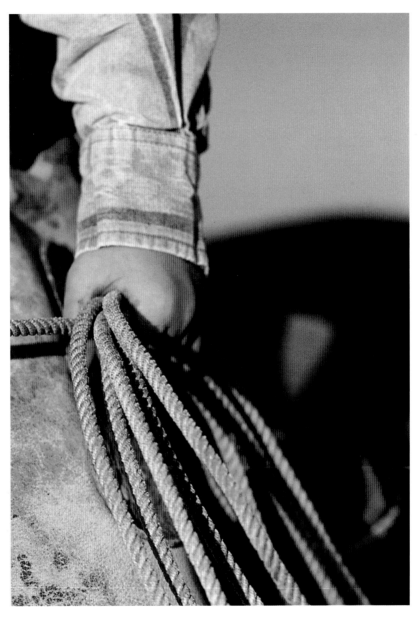

Lincoln Zollinger
Zollinger Ranch, Idaho

Holdin' steady.

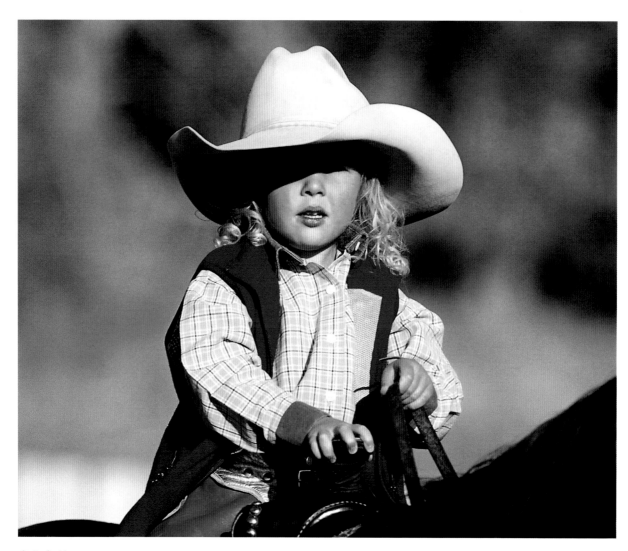

Sadie Smith
Smith Ranch, Idaho

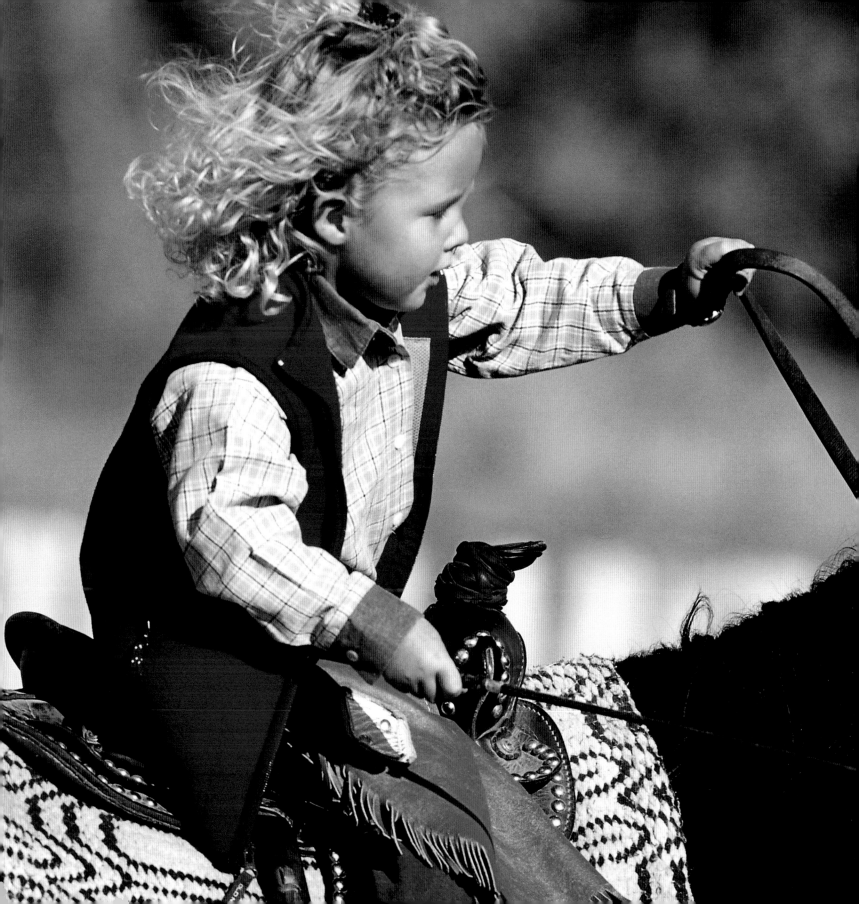

34

Doctorin'
cattle.

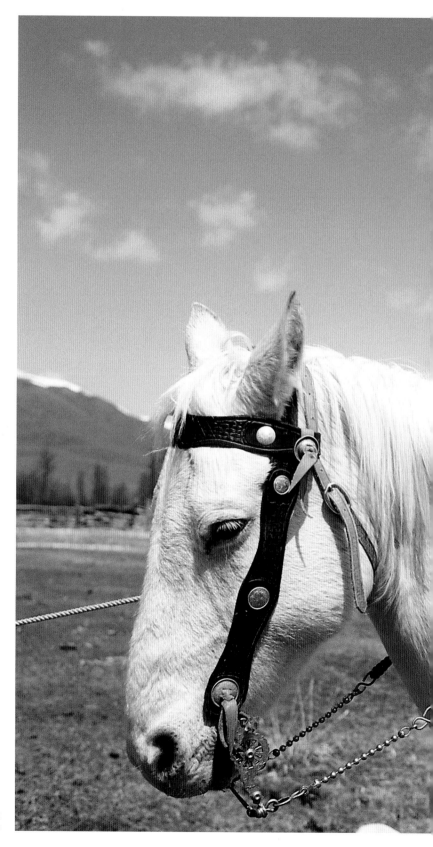

Levóon Cheyenne Hatch
Mackay, Idaho

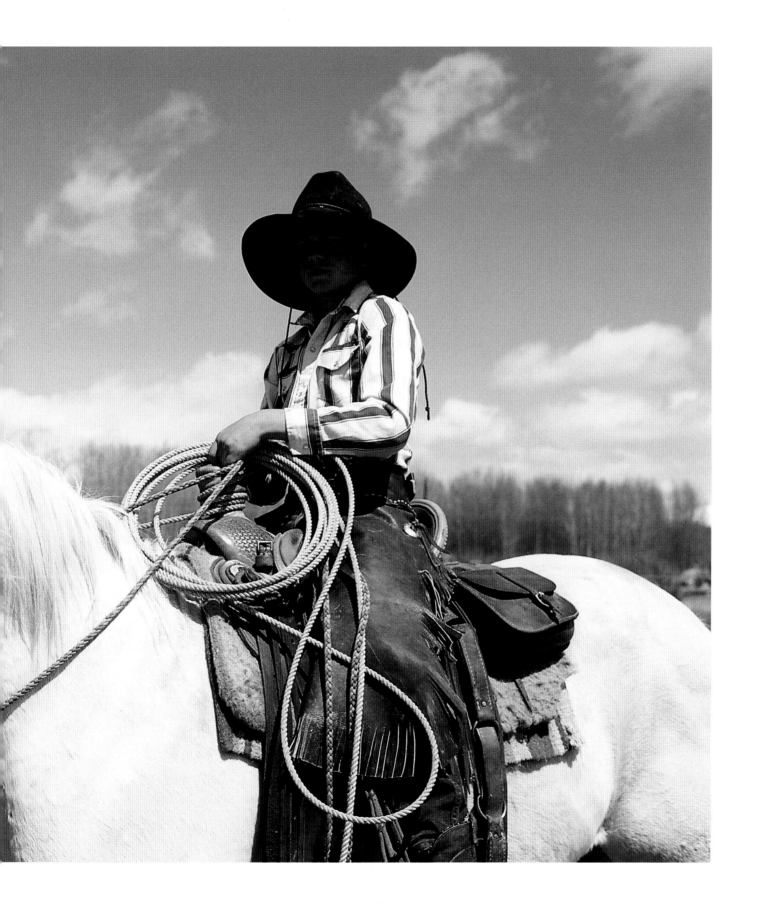

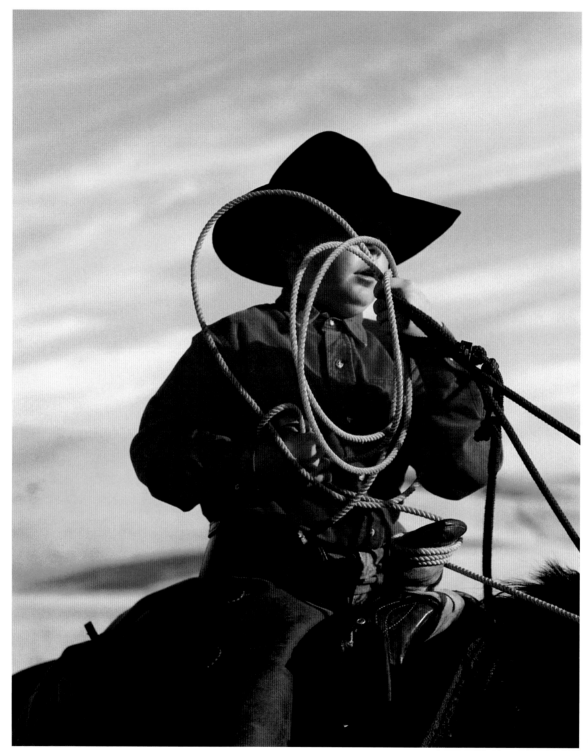

Brandon Ryan and
Doug Noblia
Tejon Ranch, California

"I can get 'em."

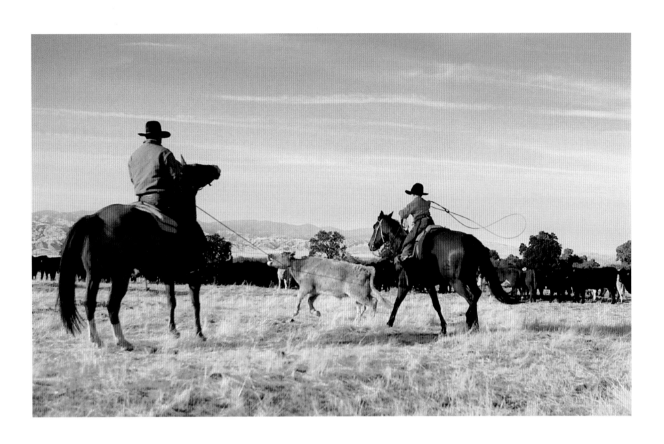

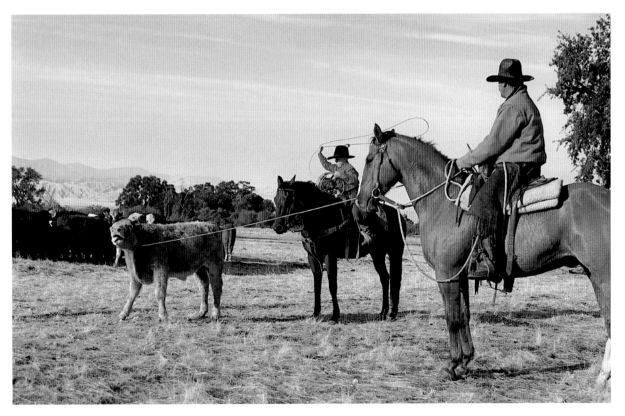

Boys
think
they are
so
funny.

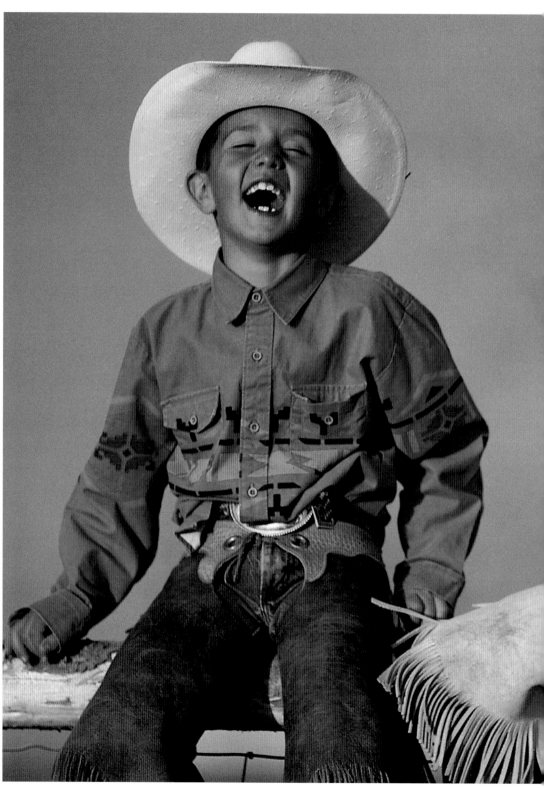

Kyle Jacobs, Shiloh Stoddard and Rita Hoggan
Stoddard Ranch, Idaho

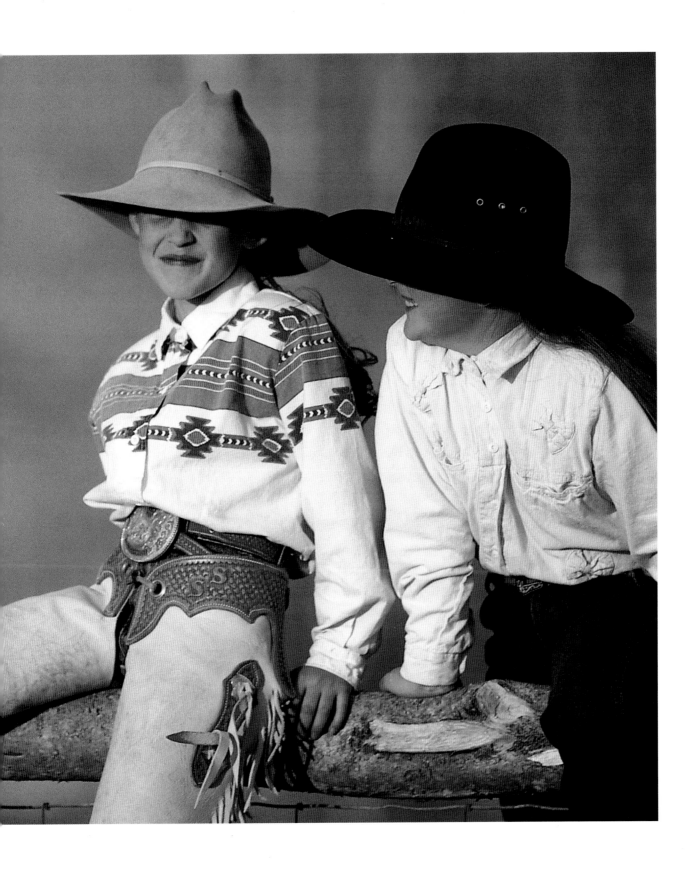

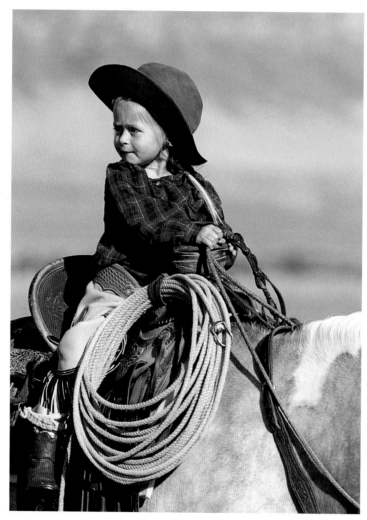

Madison Sorden
Dillon, Montana

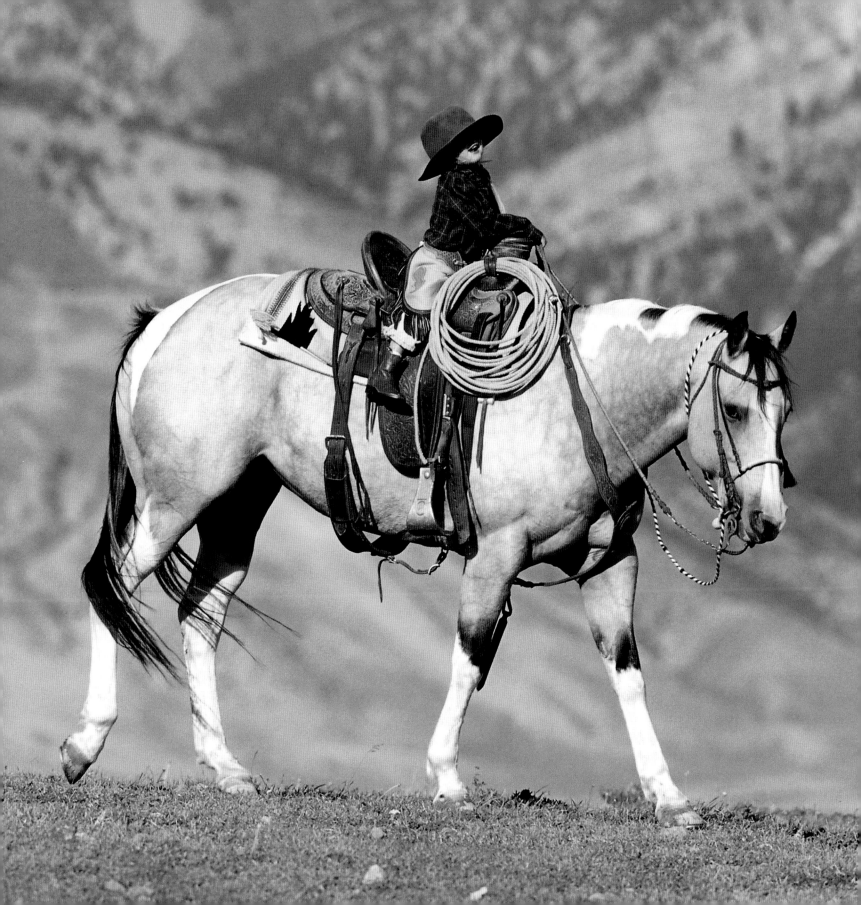

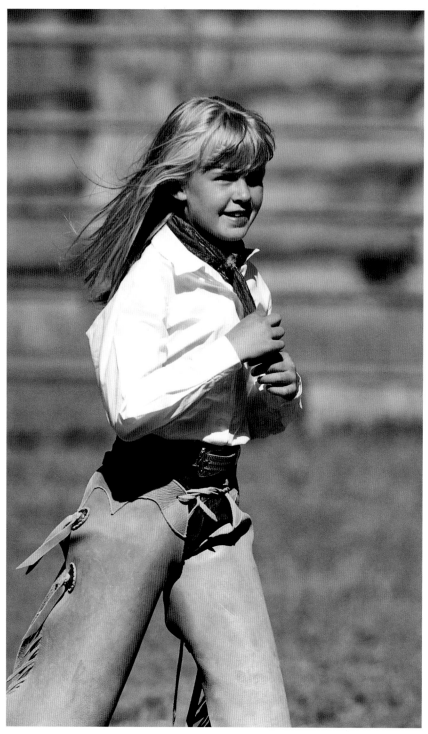

Kirby Swickard
Five Dot Land & Cattle Co., California

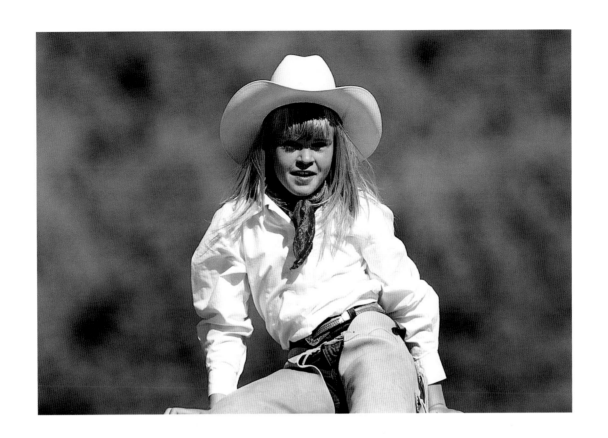

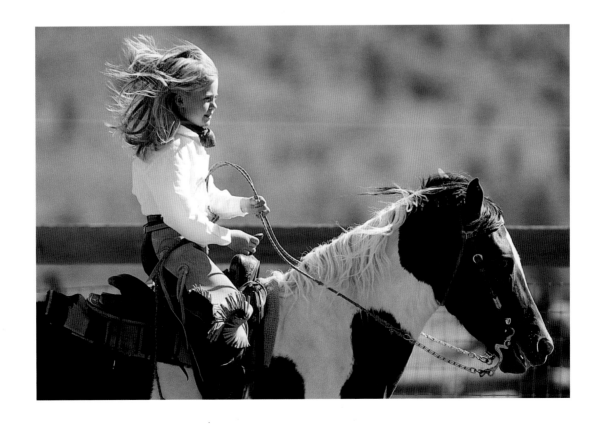

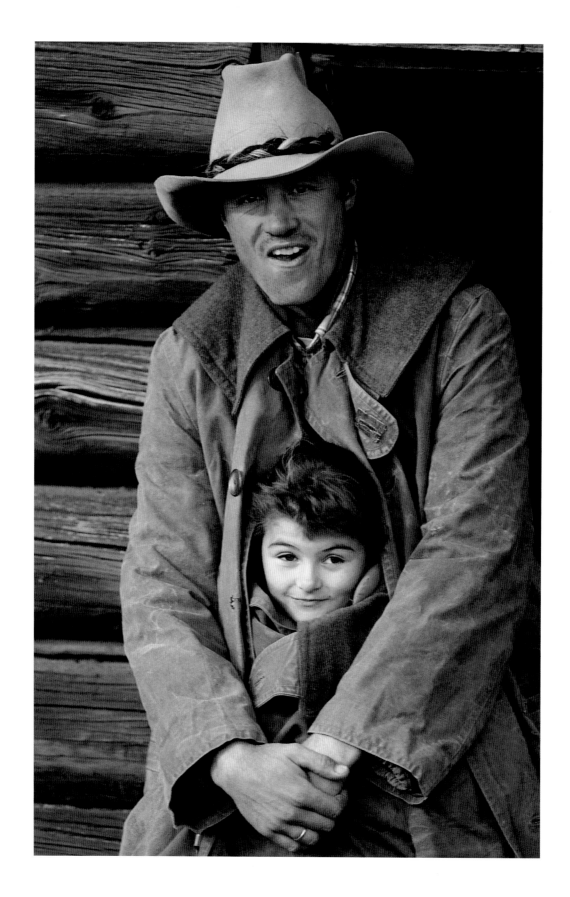

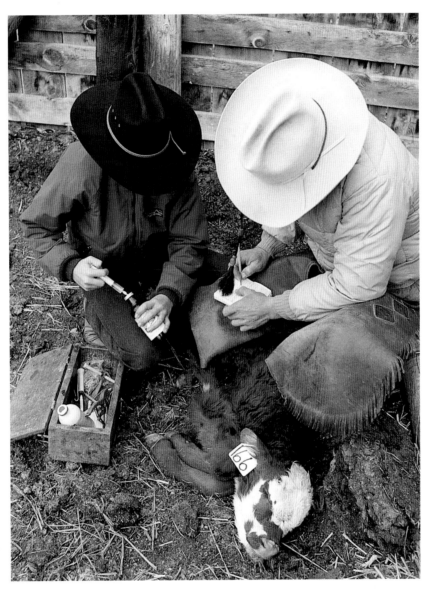

Jack and Jayme Goddard
Bar 13 Ranch, Idaho

45

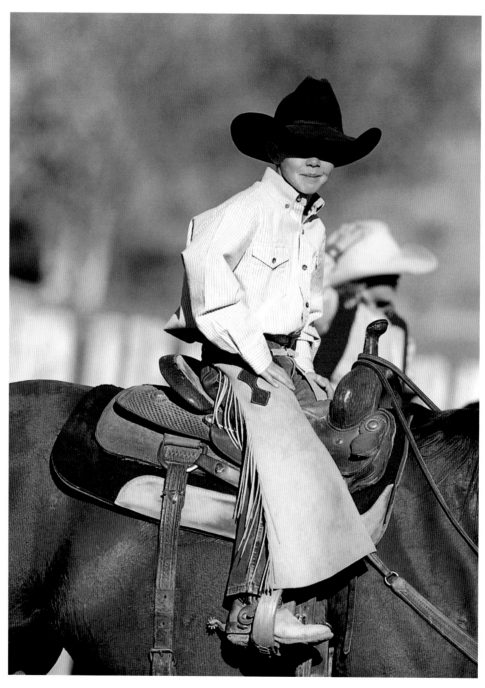

Cade Smith
Smith Ranch, Idaho

He's a cutter.

46

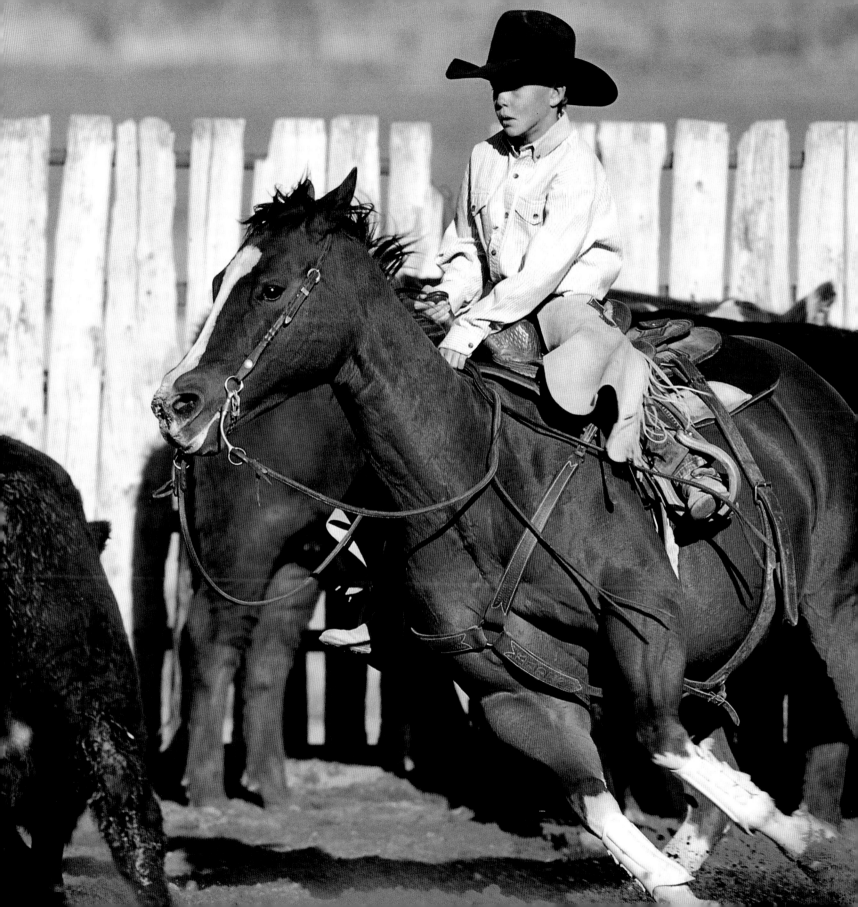

Momma, don't
let your
babies grow
up to be
cowboys.

48

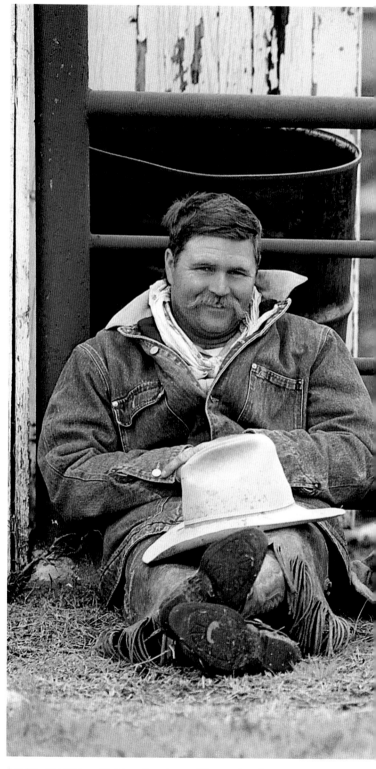

Lee Hay, Rick Wilson, Madalynn Saunders and Thomas Saunders
Twin V Ranch, Texas

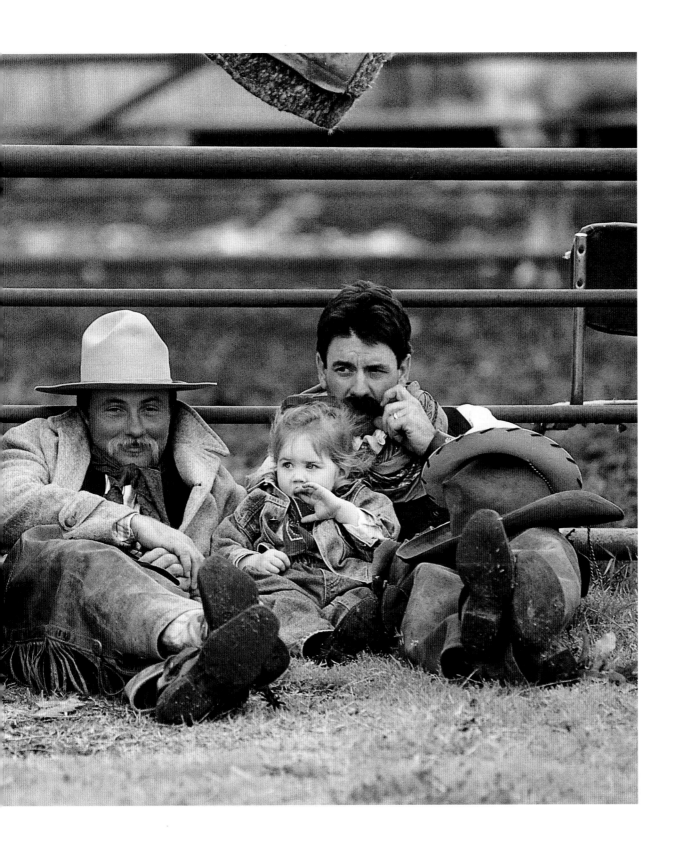

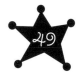

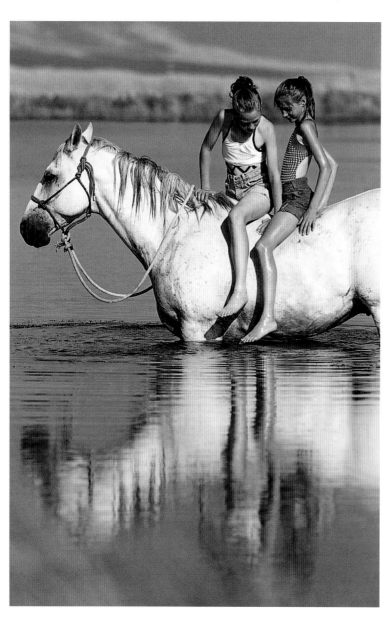

Jessica Zollinger and Chelsea Rosenkrance
The Old Swimming Hole, Mackay, Idaho

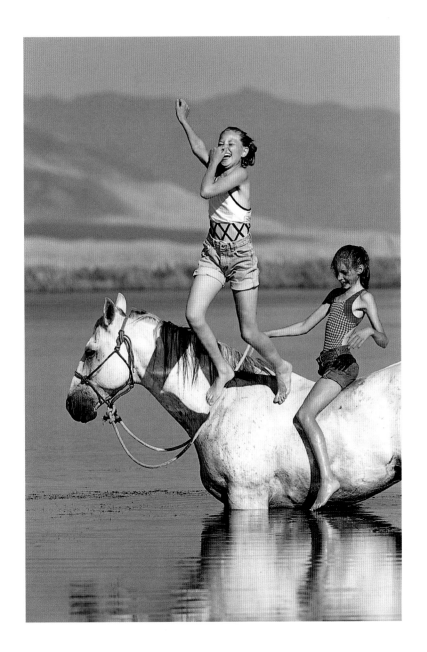

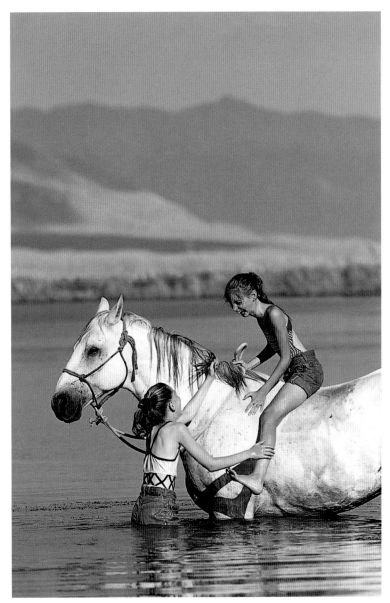

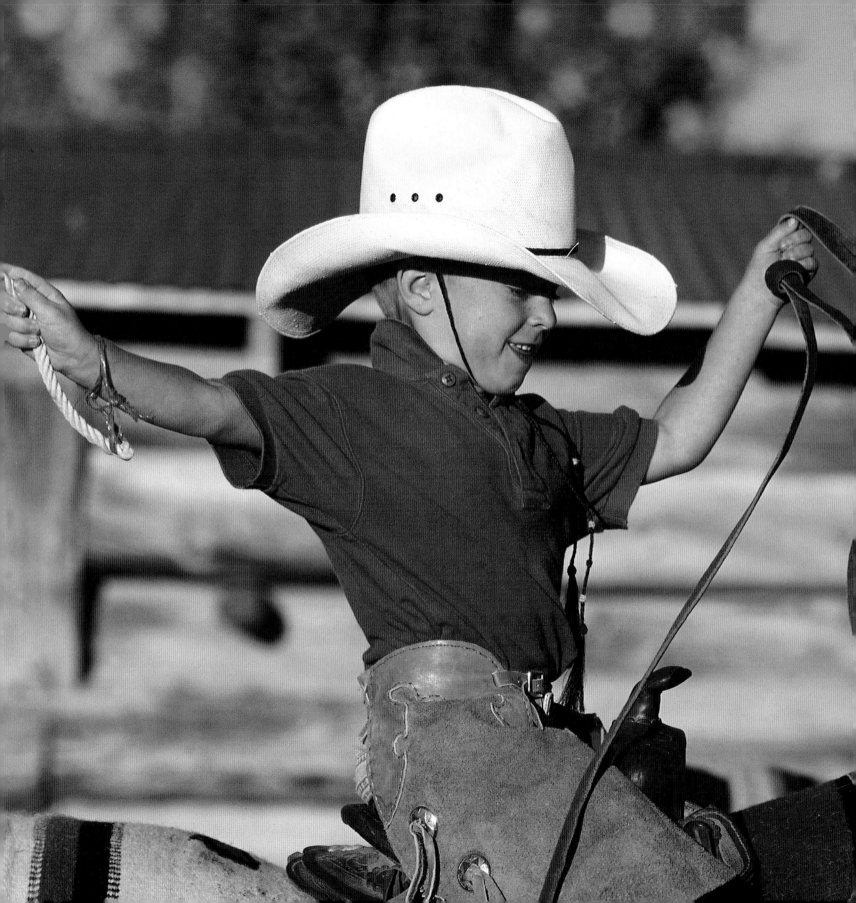

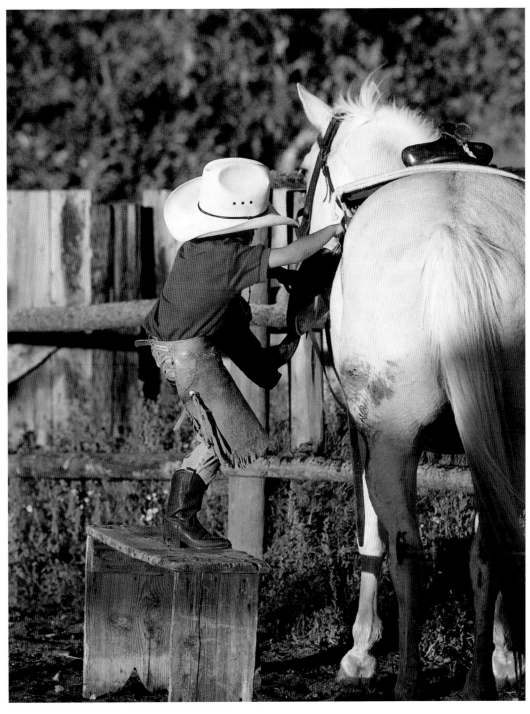

Colby Stoecklein riding Old Silk.

"Please don't move"

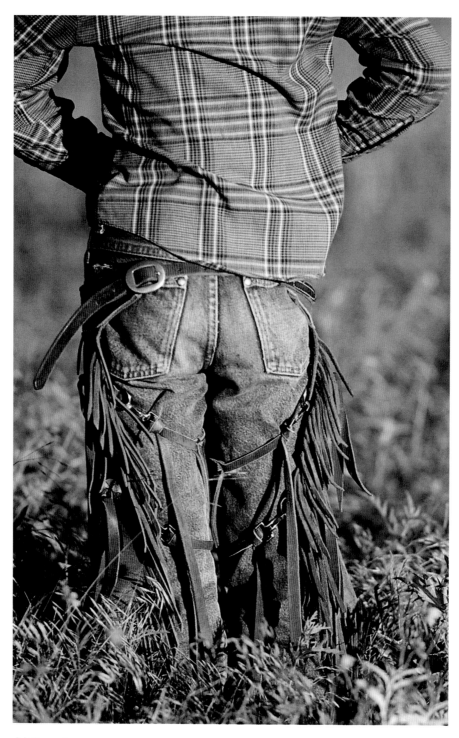

RA Brown II
R.A. Brown Ranch, Texas

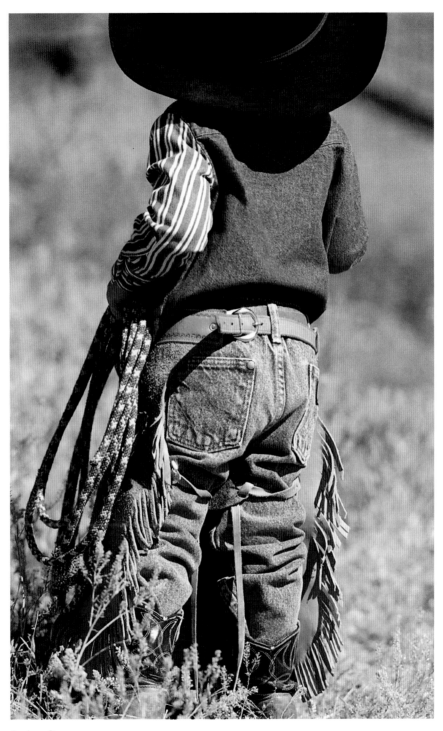

Lanham Brown
R.A. Brown Ranch, Texas

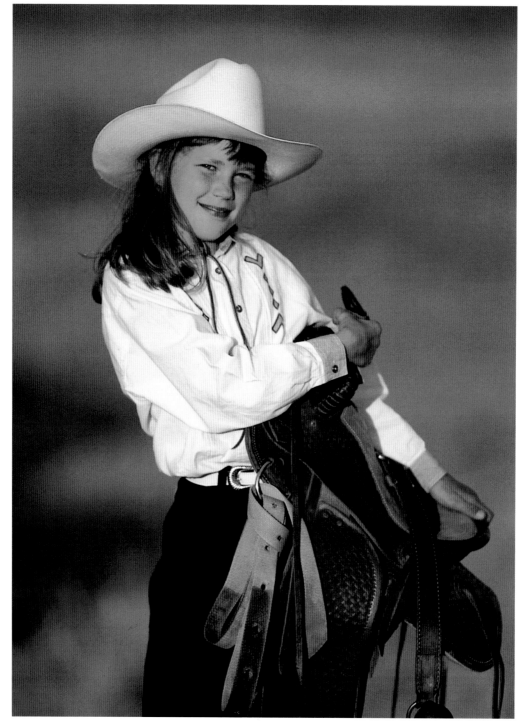

Jessica Zollinger
Zollinger Ranch, Idaho

What a smile!

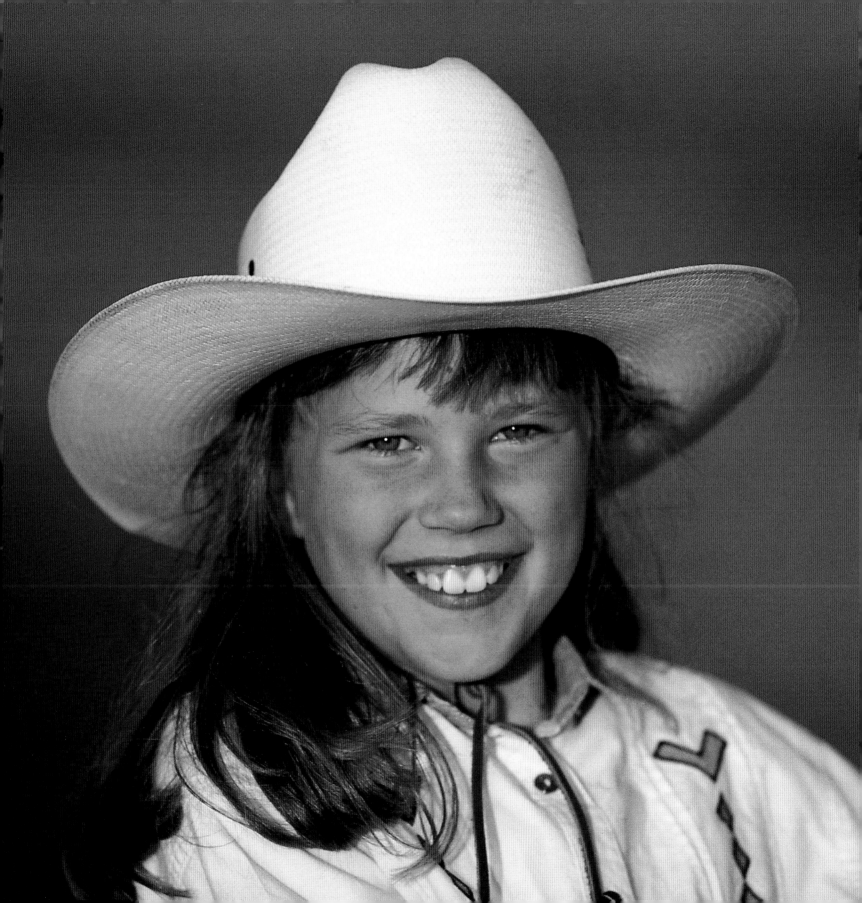

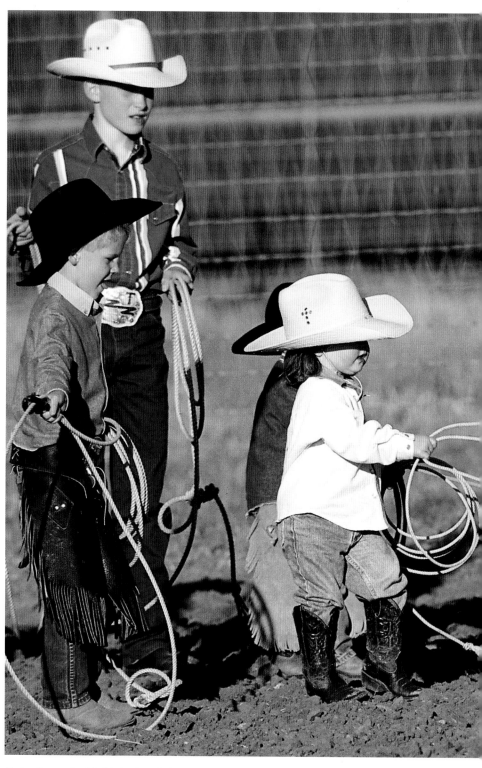

Who's next?

Tucker Brown, Brad Bellah, Lanham, Lydia and Myles Brown, Emily McCartney, and Griffin Brown
R.A. Brown Ranch, Texas

58

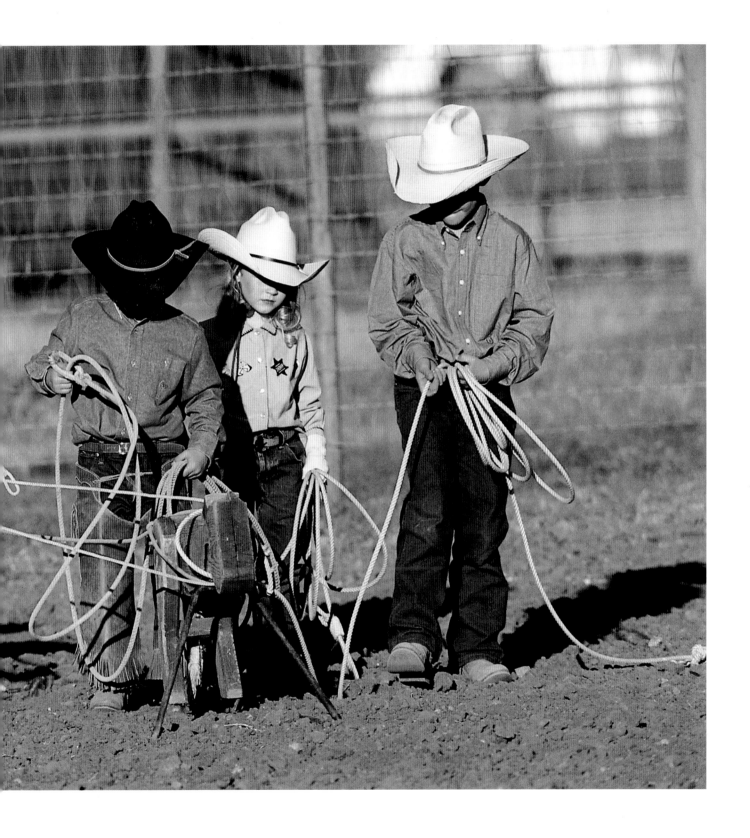

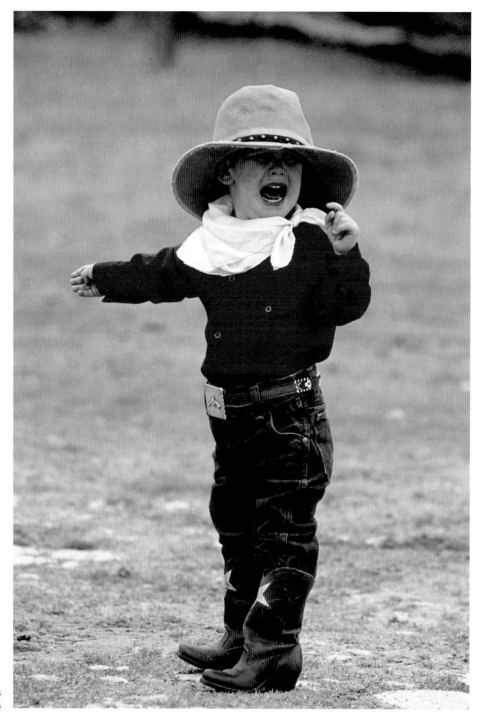

Jordan Williams
Twin V Ranch, Texas

"My cousin did it!"

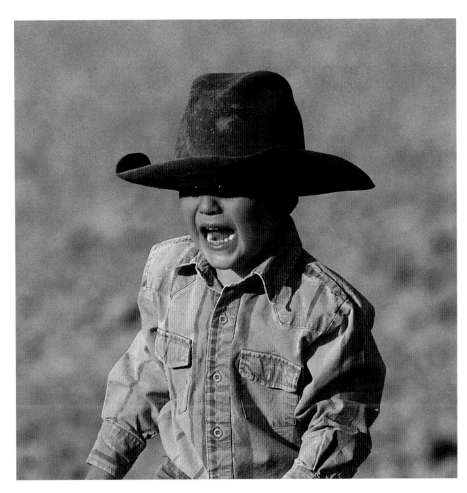

Lincoln Zollinger
Zollinger Ranch, Idaho

"My sister did it!"

"My turn."

Griffin Brown
R.A. Brown Ranch, Texas

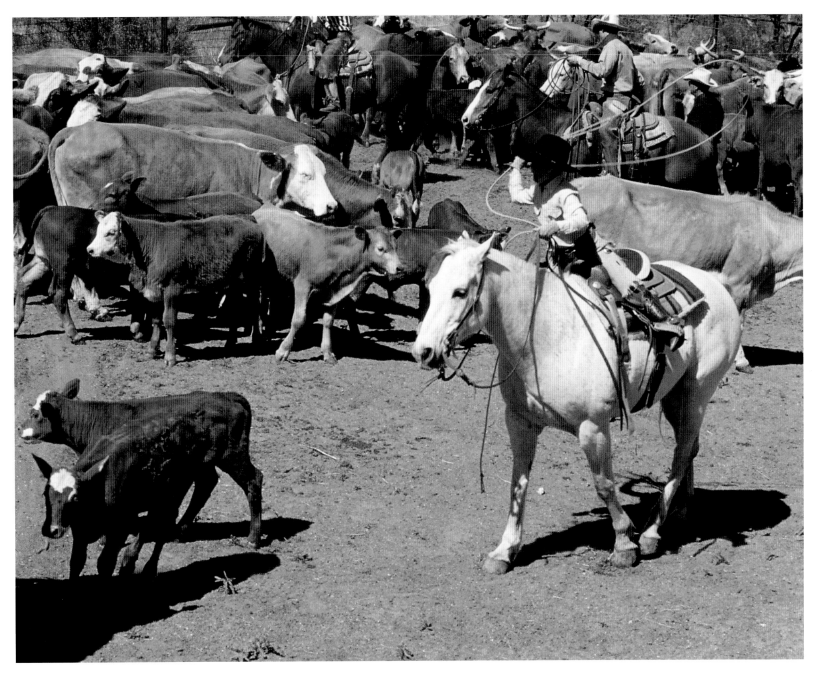

RA Brown II
R.A. Brown Ranch, Texas

"Stand still now."

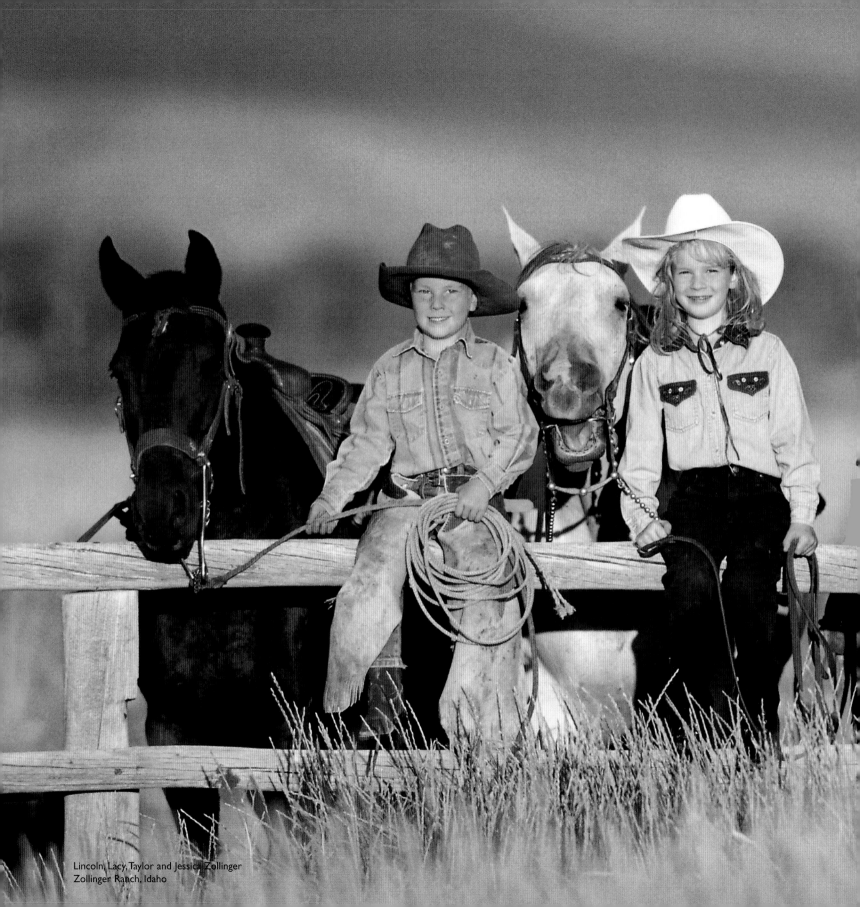

Lincoln, Lacy, Taylor and Jessica Zollinger
Zollinger Ranch, Idaho

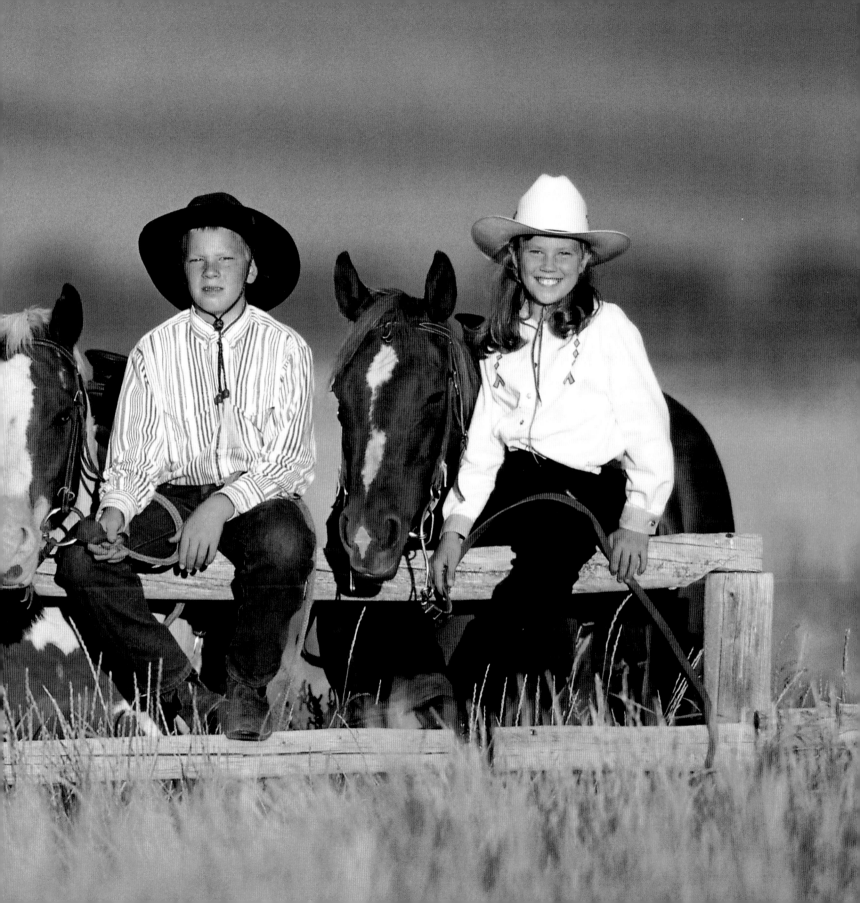

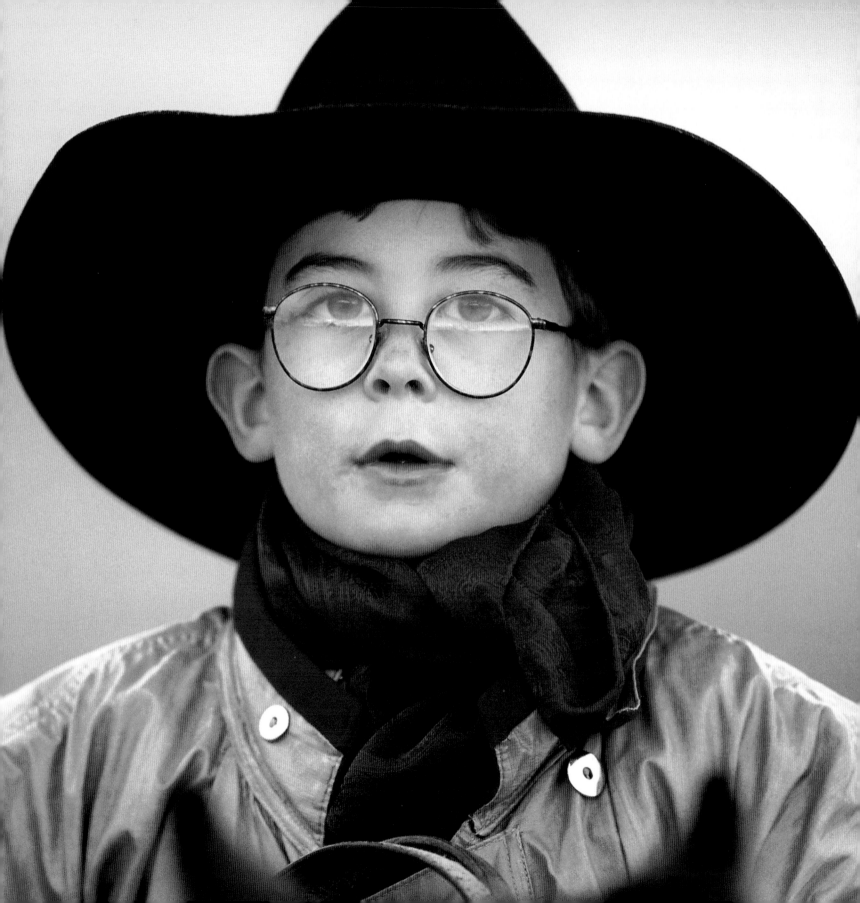

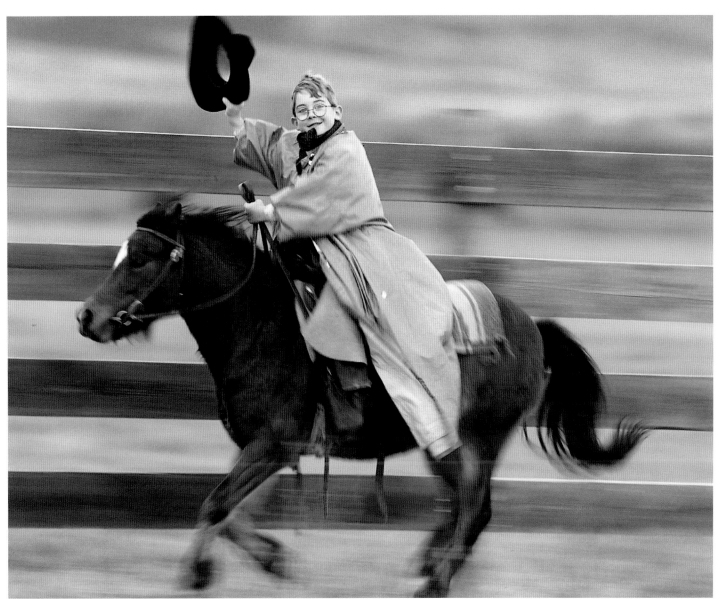

John Selby
Sieben Livestock, Montana

Cute
as a
button.

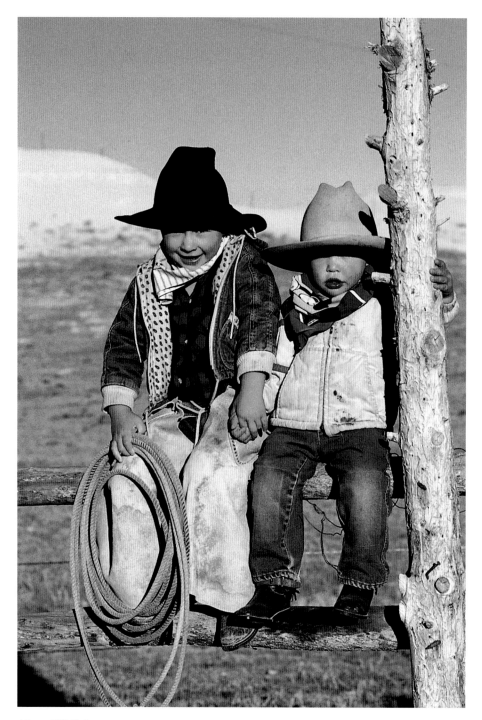

Jake and J.R. Steiner
Steiner Ranch, Idaho

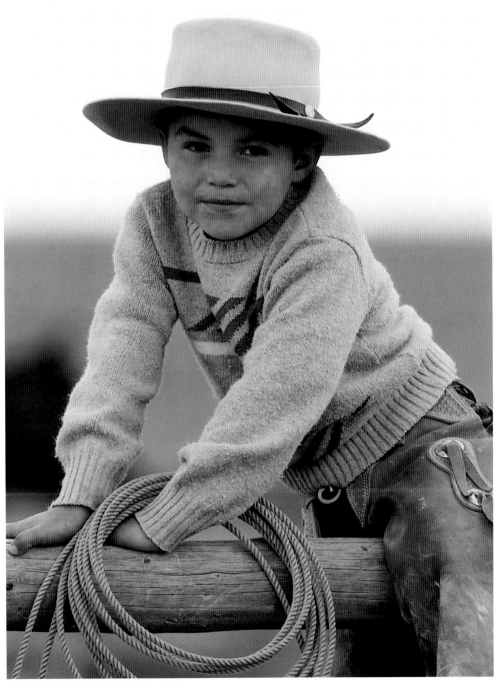

Junior Kelly
Y.P. Ranch, Nevada

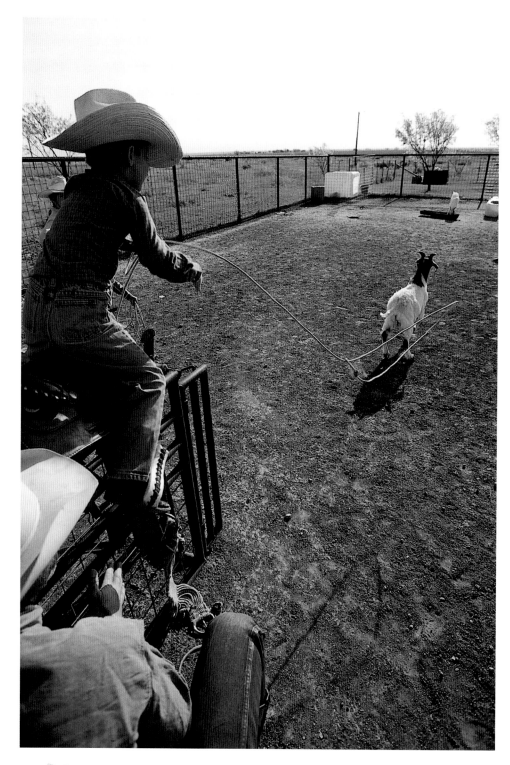

Practicing on the old goat.

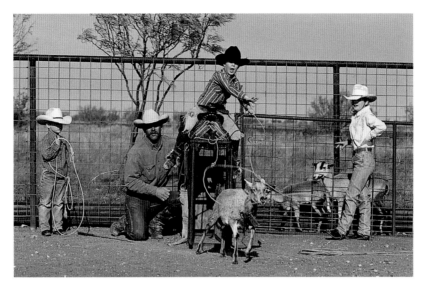

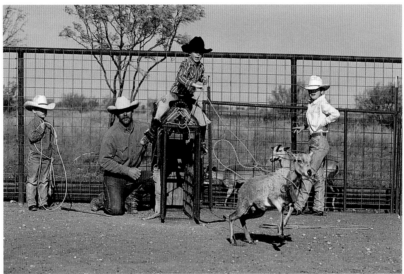

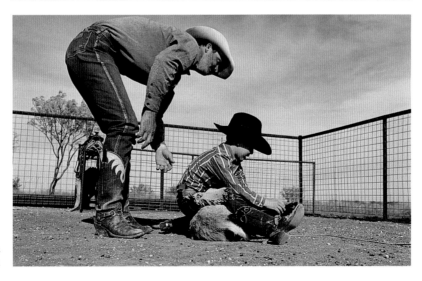

Rob A. Brown and the kids
work on their roping.

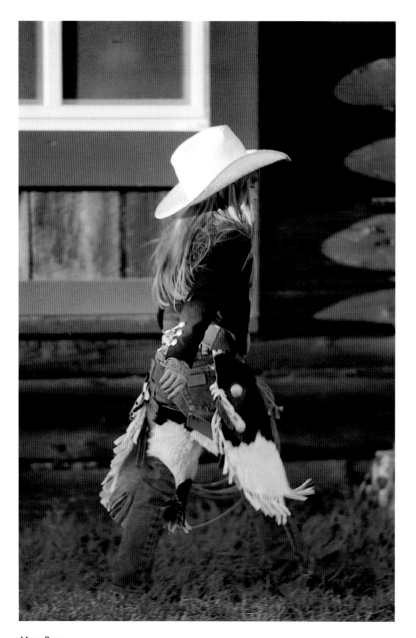

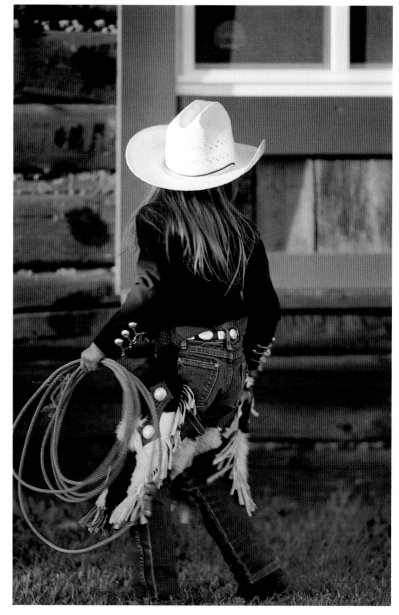

Mesa Pate
Pate Ranch, Montana

Mom does it?"

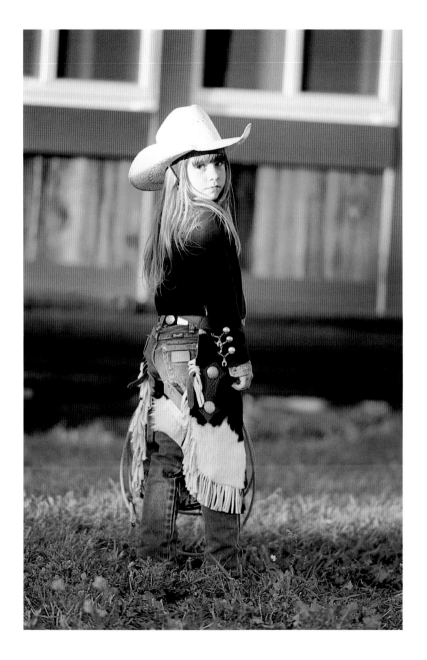

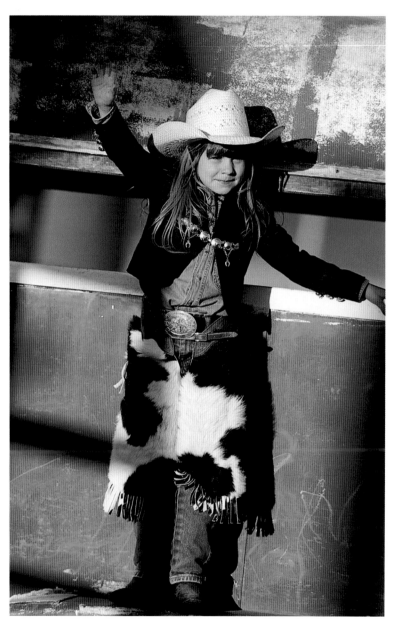

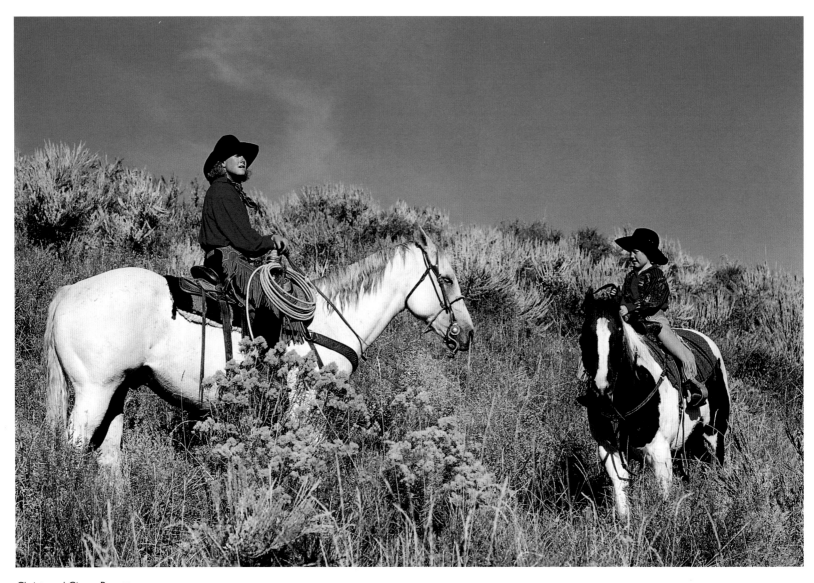

Christy and Ginger Barrett
Barrett Ranch, Idaho

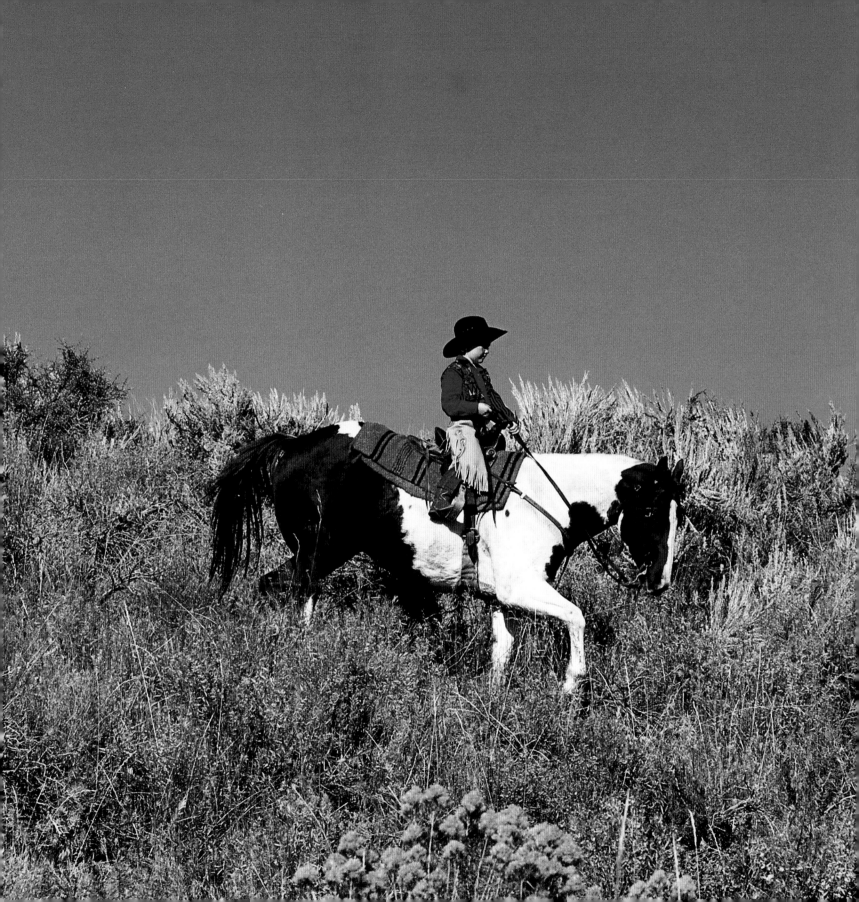

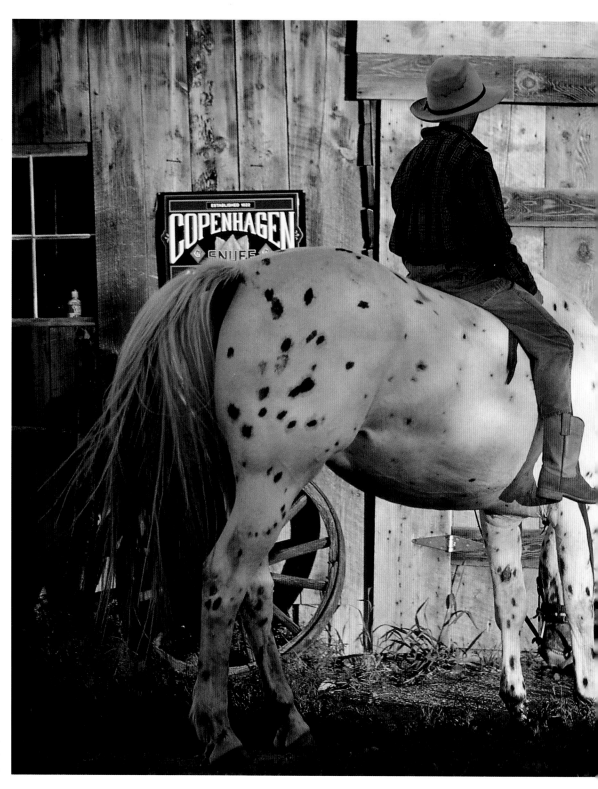

The Stoecklein boys: Drew, Taylor
and Colby with Tater
Bar Horseshoe Ranch, Mackay, Idaho

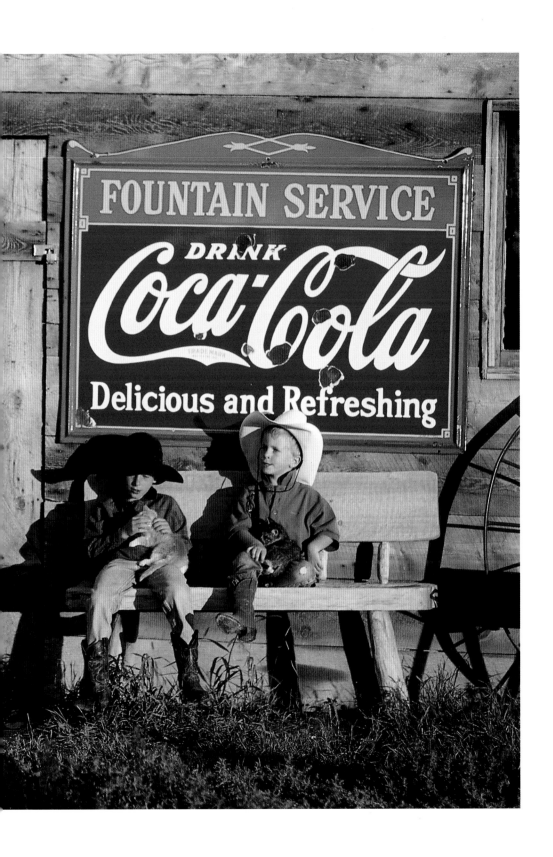

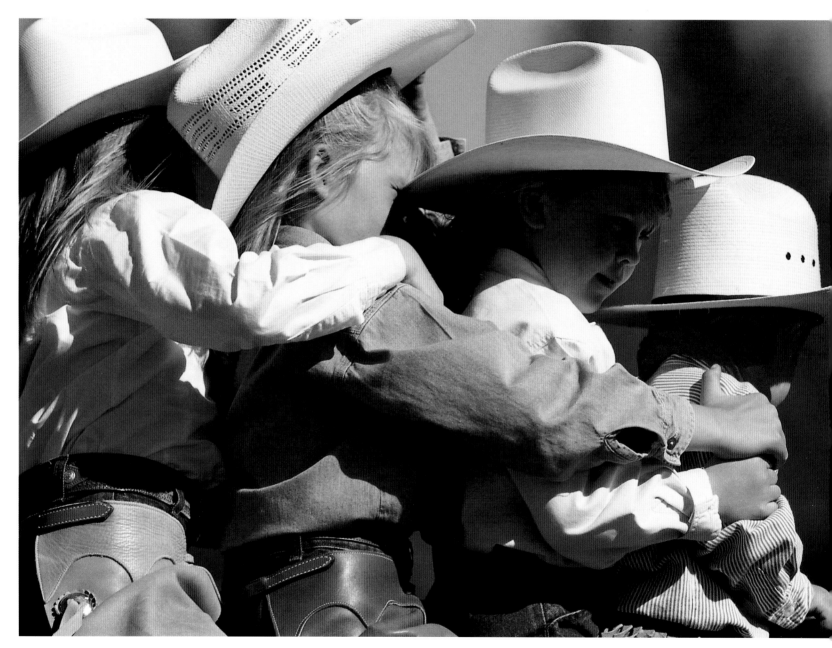

Kirby, Lindsey, Katlin and Logan Swickard
Five Dot Land & Cattle Co., Susanville, California

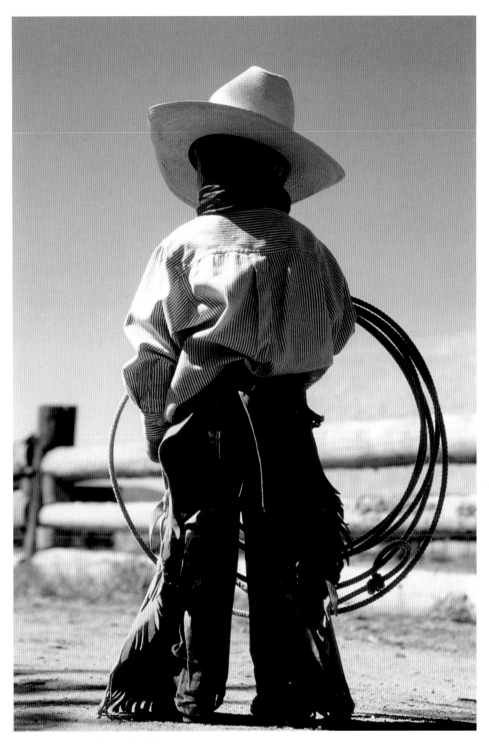

Kirby Swickard—a future John Wayne.

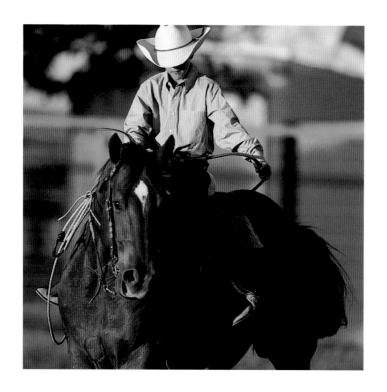
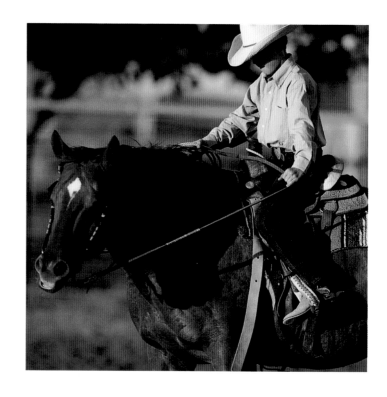
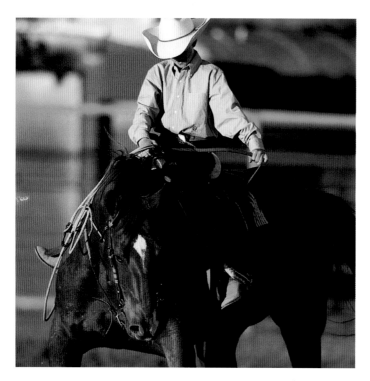
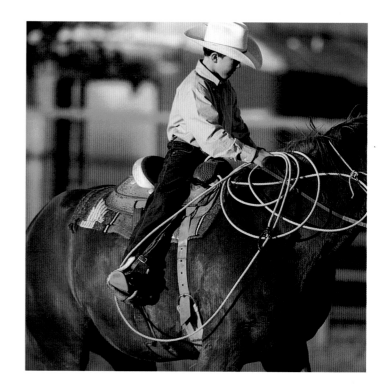

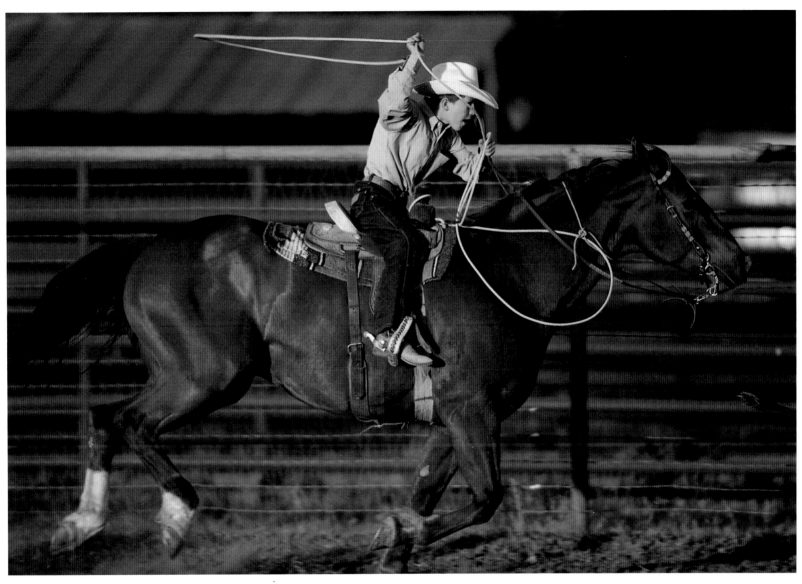

RA Brown II
R.A. Brown Ranch, Texas

Tuned up and ready to go.

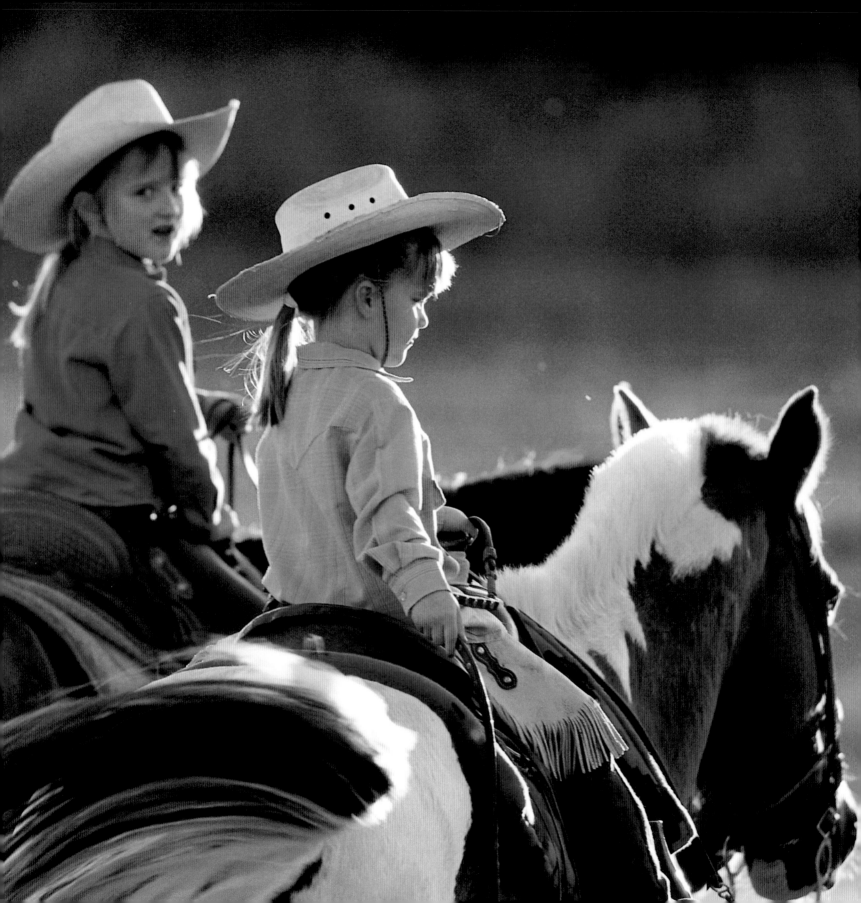

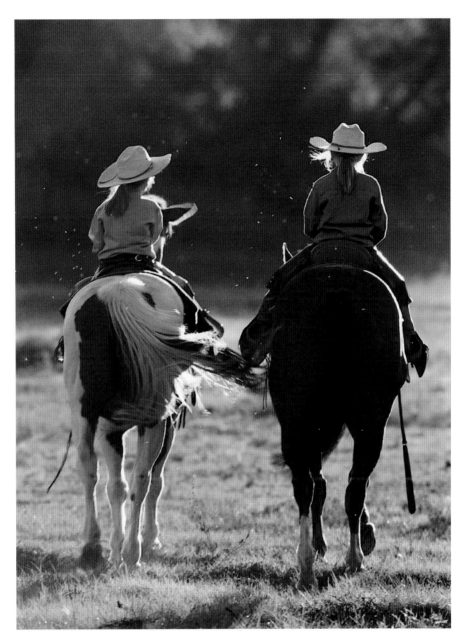

Bailey and Sami Bachman
Bachman Ranch, Idaho

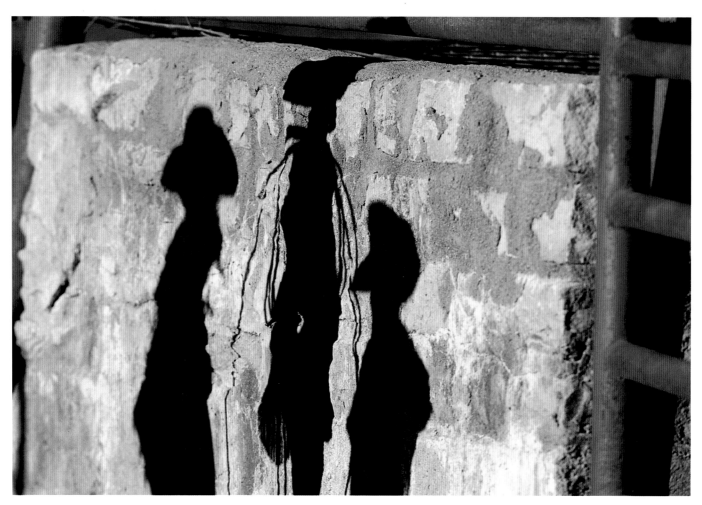

Shadows
R.A. Brown Ranch, Texas

84

Jordan Williams
Twin V Ranch, Texas

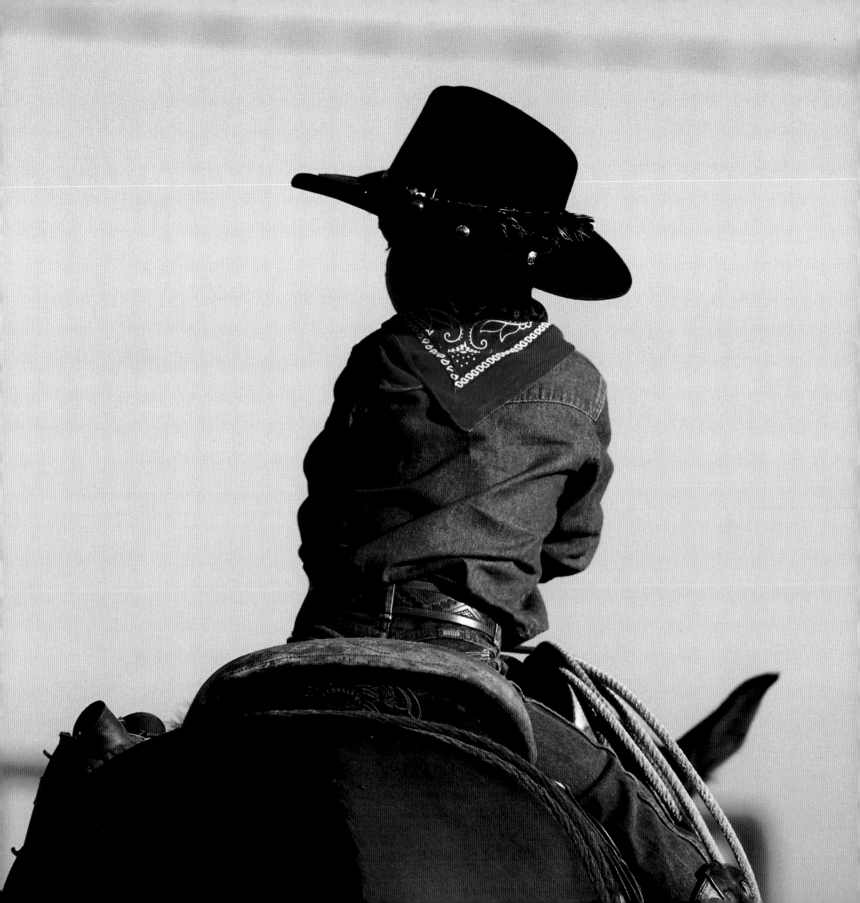

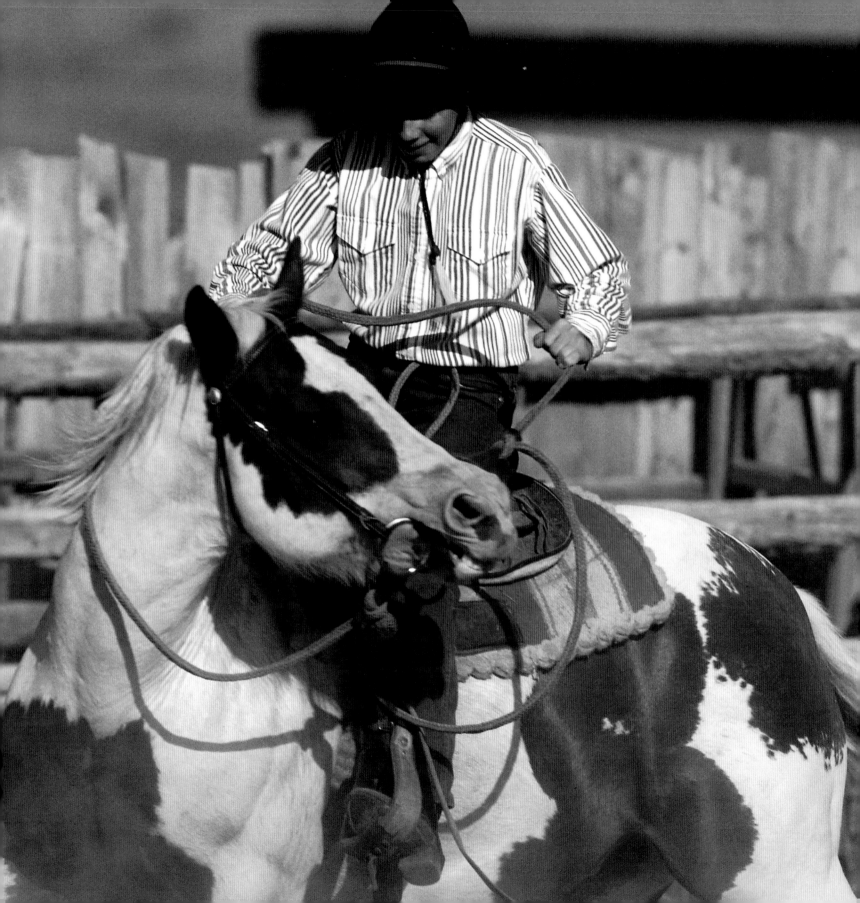

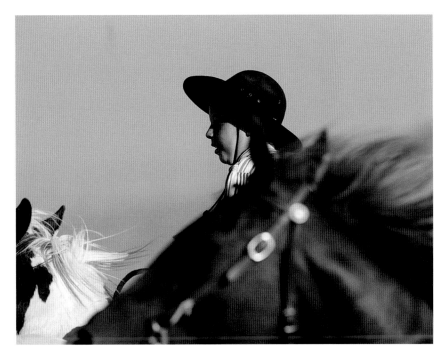

Tyler Zollinger
Zollinger Ranch, Idaho

Tuning up Old Paint.

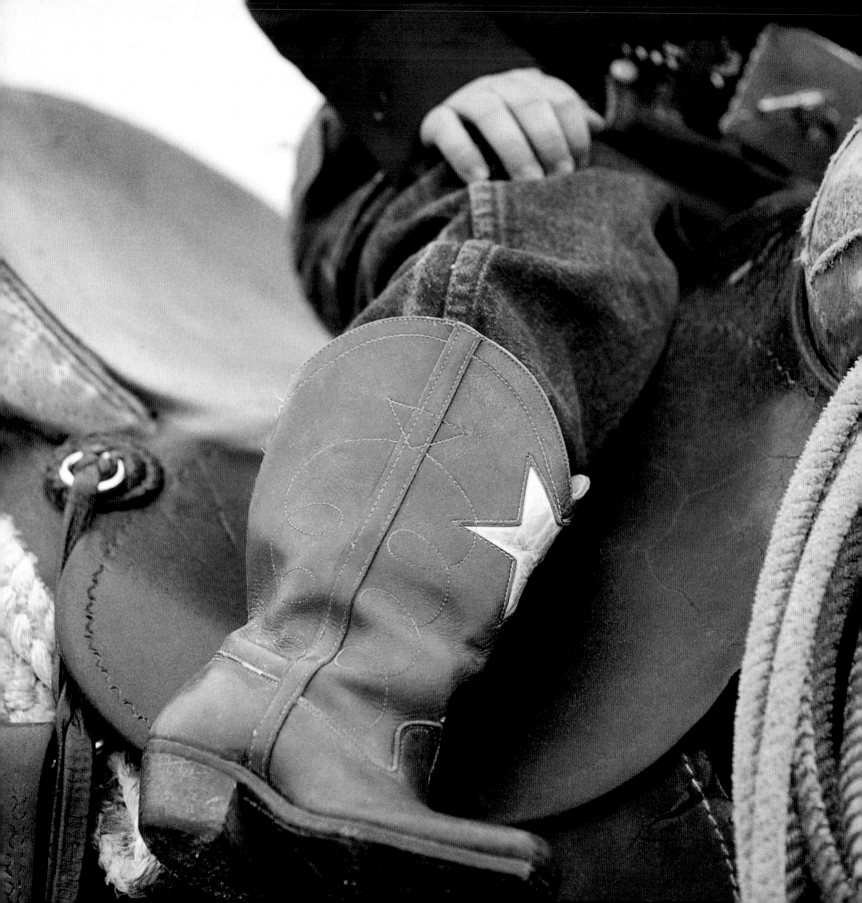

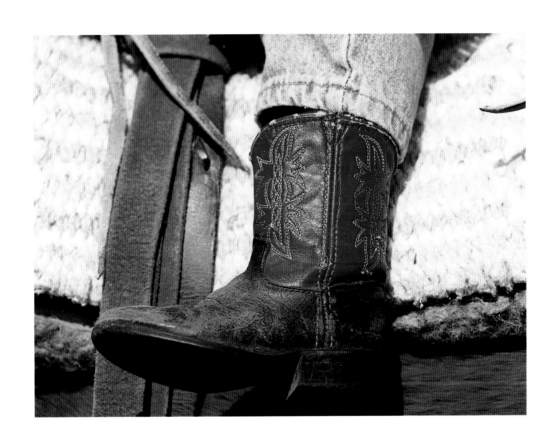

Boots never wear out, they just get passed on down.

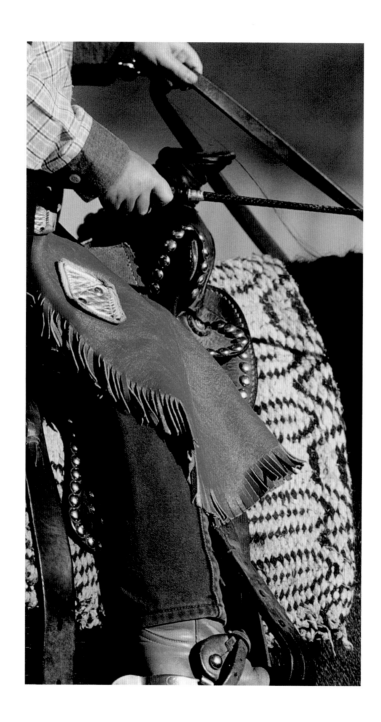

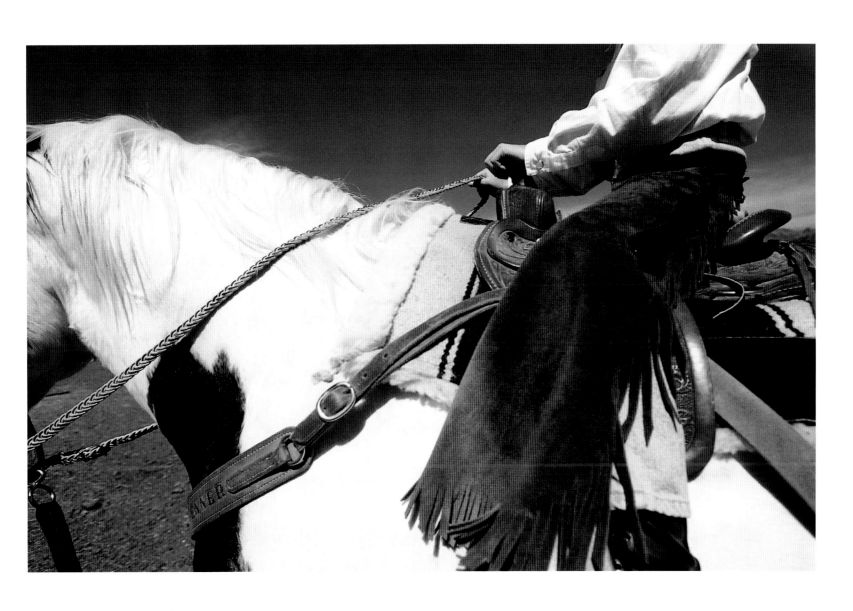

Girls get the pretty chaps.

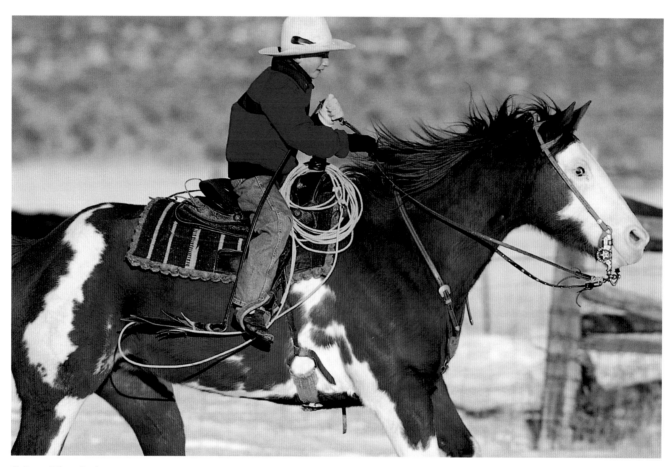

Quirt and Dave Boyles
Boyles Ranch, Idaho

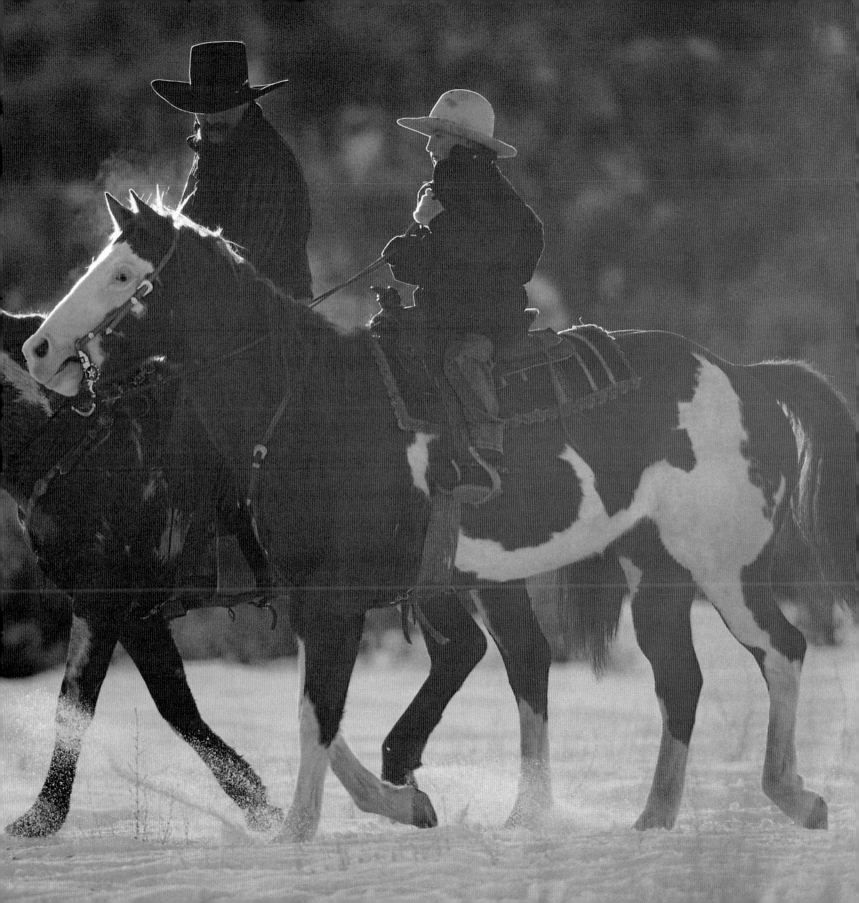

The

boys

get

the

pig.

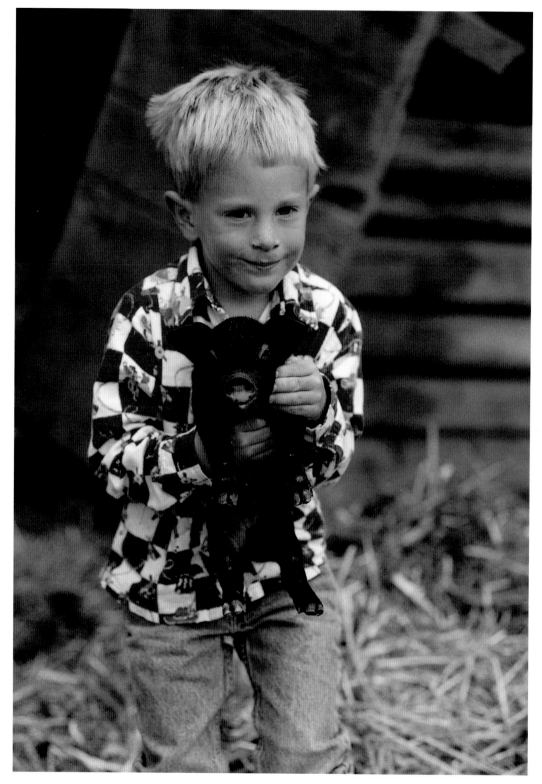

Taylor Stoecklein
Idaho

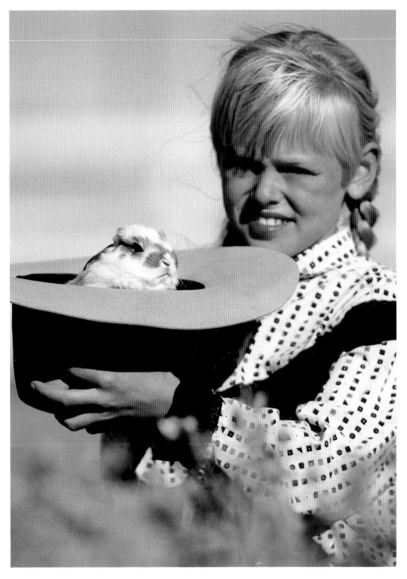

The girls get the bunny.

Cassie Funkhouser
Idaho

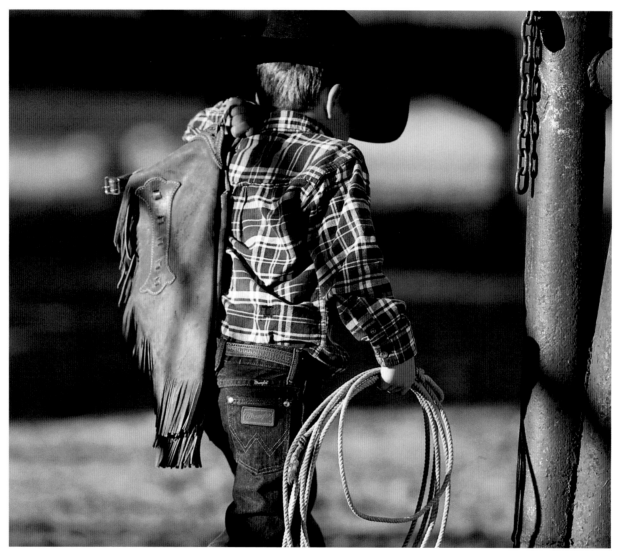

Griffin Brown
R.A. Brown Ranch, Texas

"I'm going to work."

"Please..."

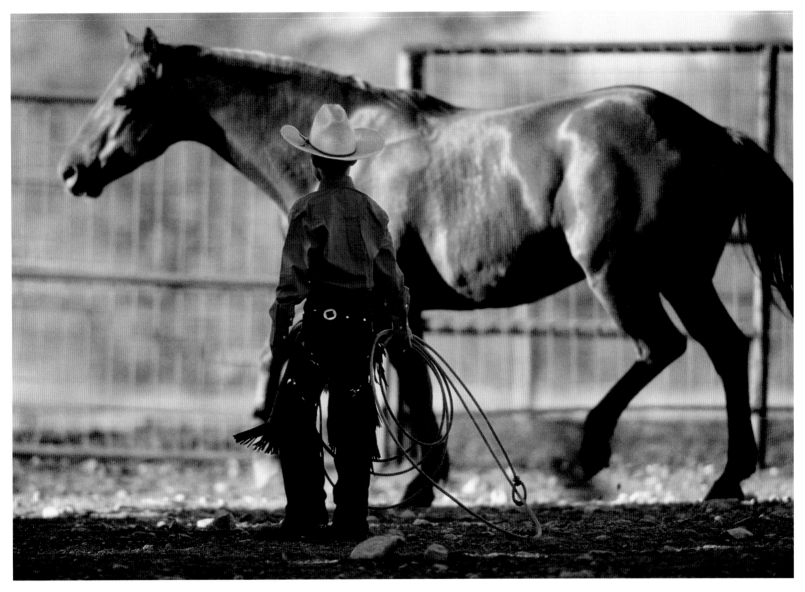

RA Brown II
R.A. Brown Ranch, Texas

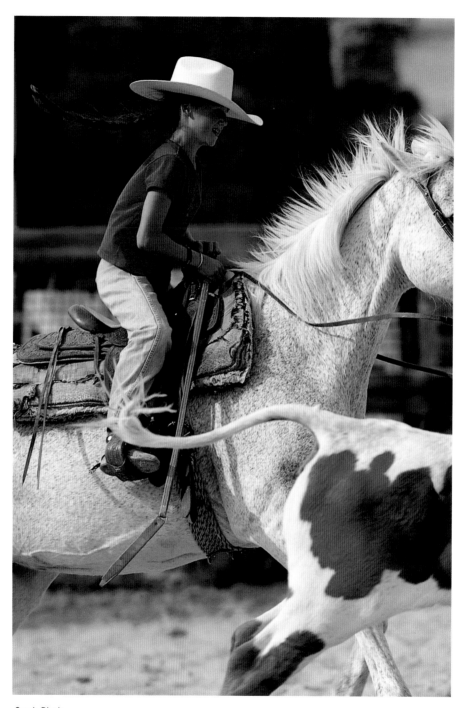

Sarah Black
Martin & Elaine Black Ranch, Idaho

98

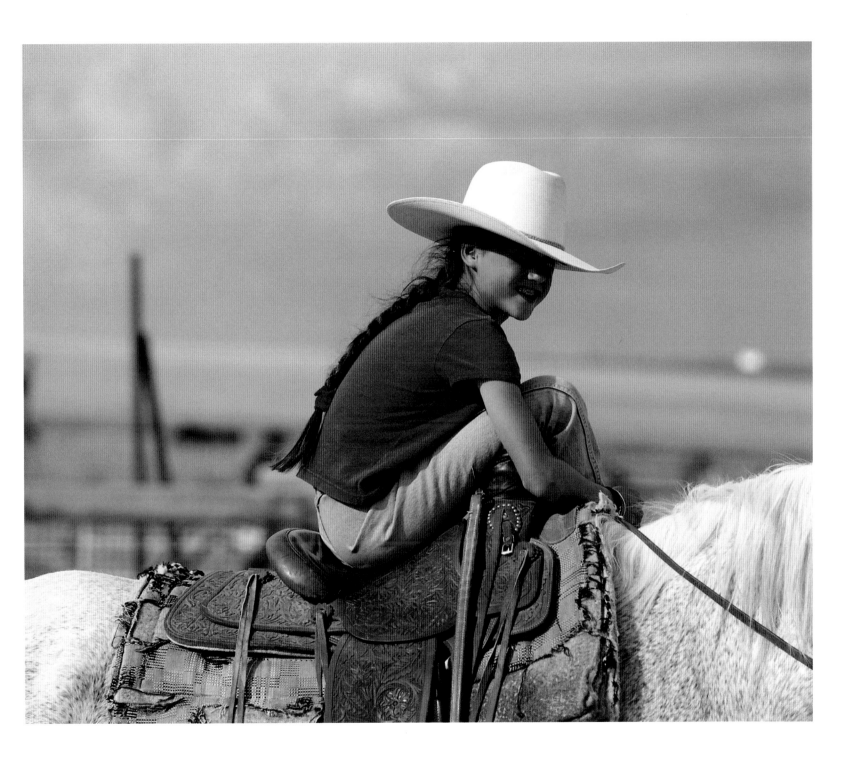

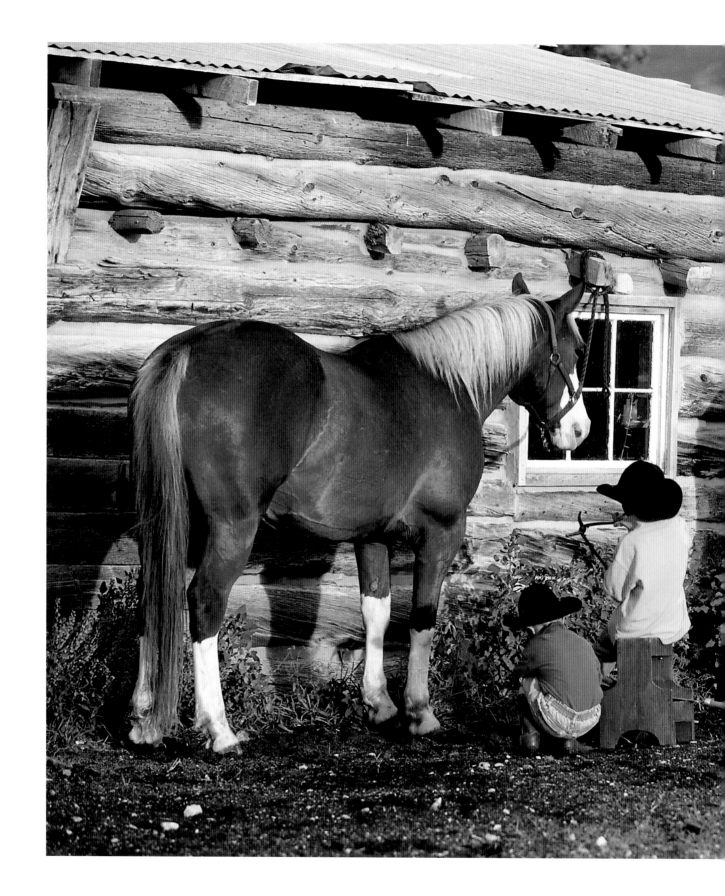

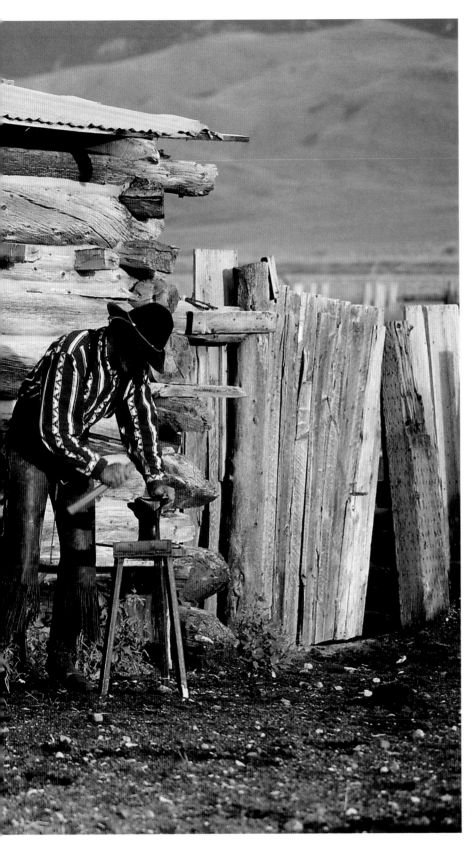

"What do
you think
you do
with these?"

Taylor and Colby Stoecklein help Derrick Pike.
Mackay, Idaho

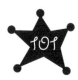
101

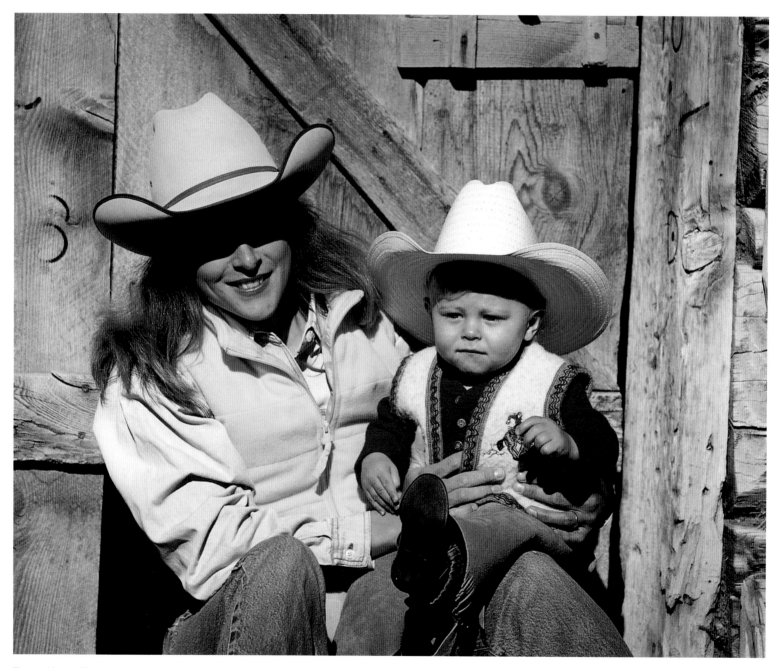

Tara and Jaysen Petersen
Dillon, Montana

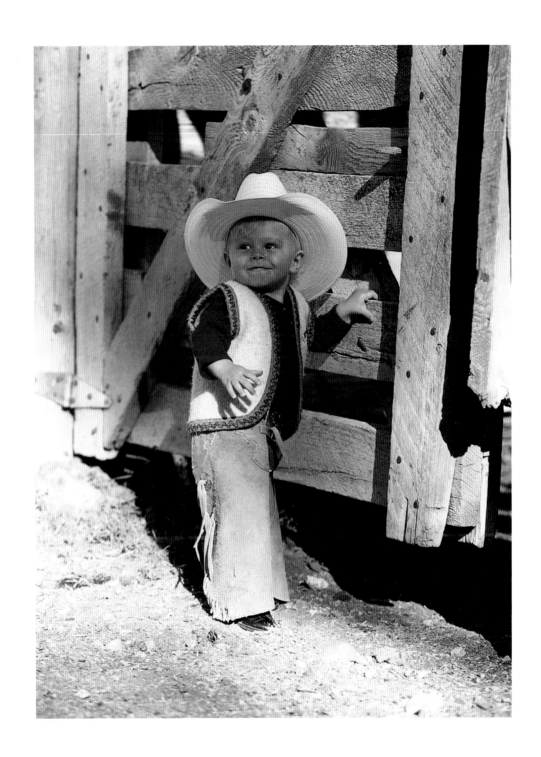

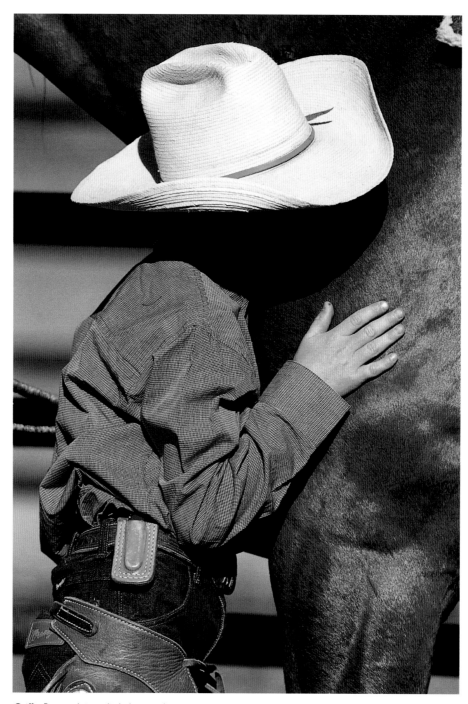

Griffin Brown doing a little horse whispering.
Throckmorton, Texas

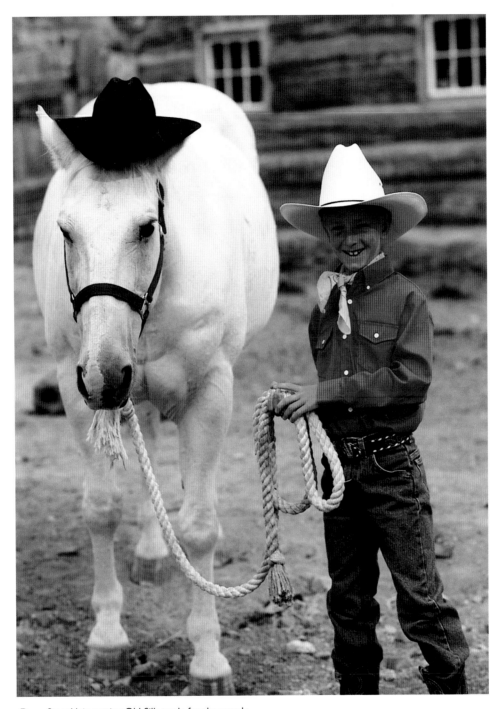

Drew Stoecklein getting Old Silk ready for the parade.
Mackay, Idaho

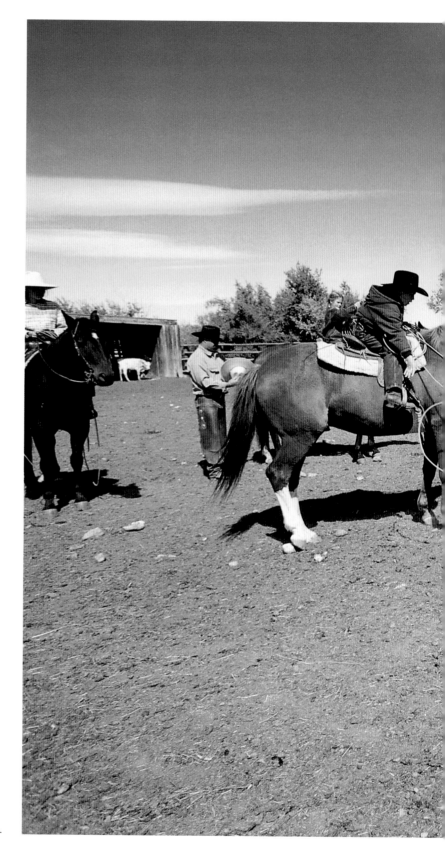

Cody Morgan catching two feet at
Broken River Ranch, Mackay, Idaho.

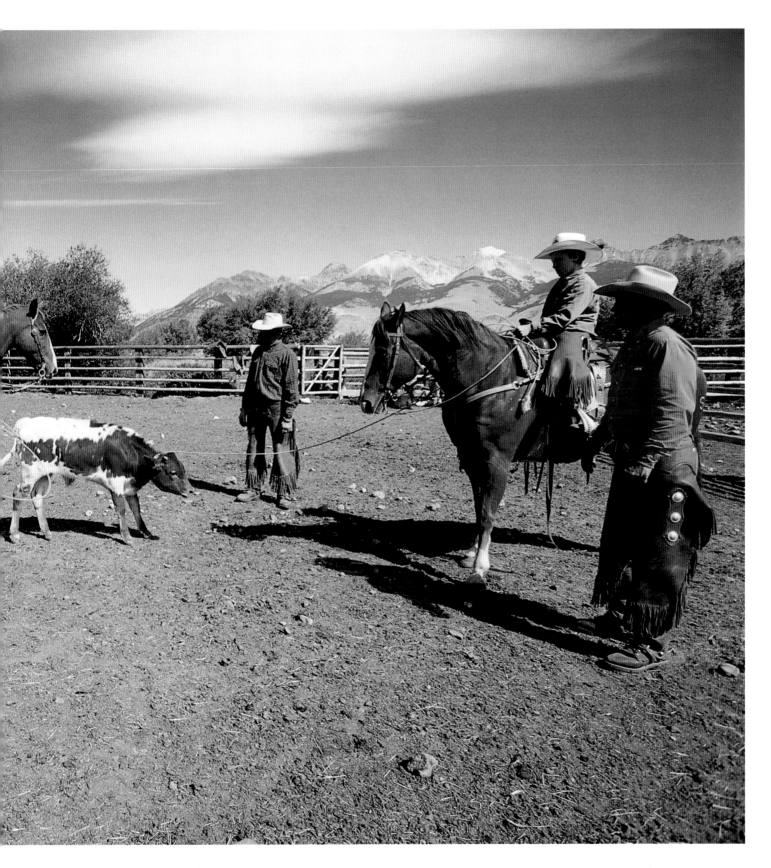

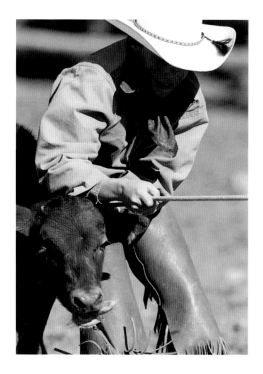
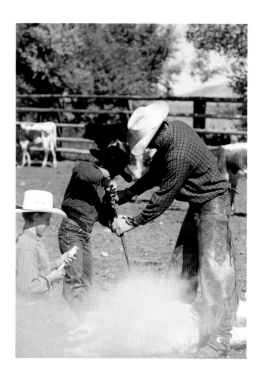
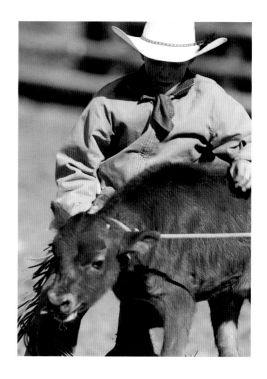
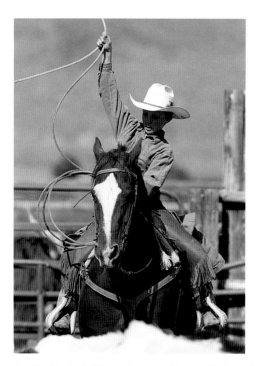
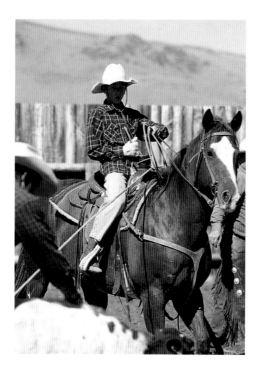
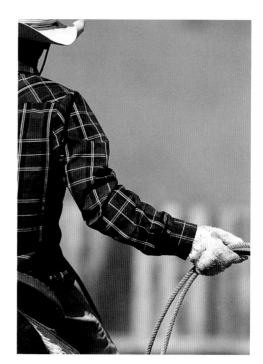

Eric Shields, Cody Morgan, Jessica and Lincoln Zollinger, Kindee Wilson and Taylor Stoecklein
Broken River Ranch, Idaho

108

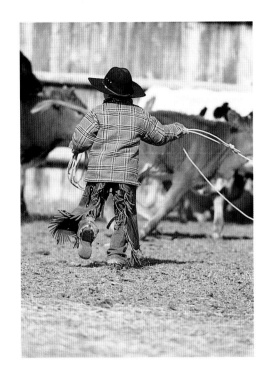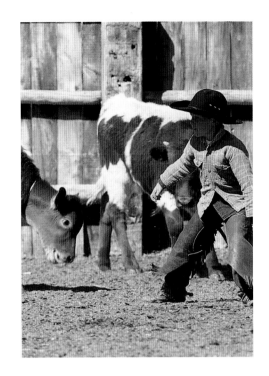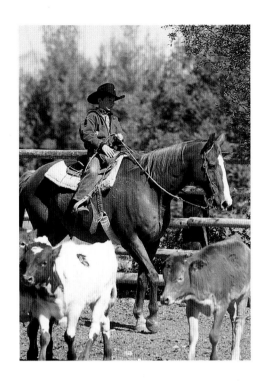

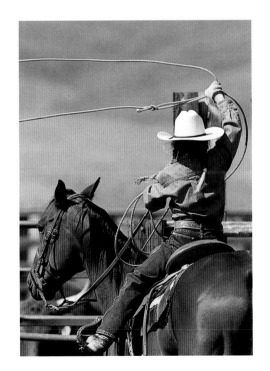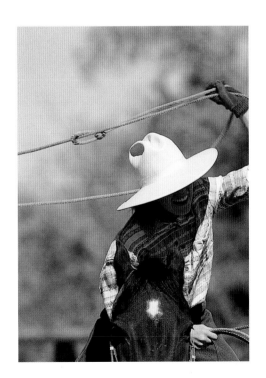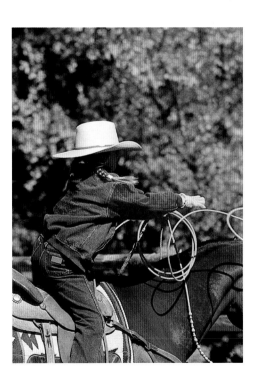

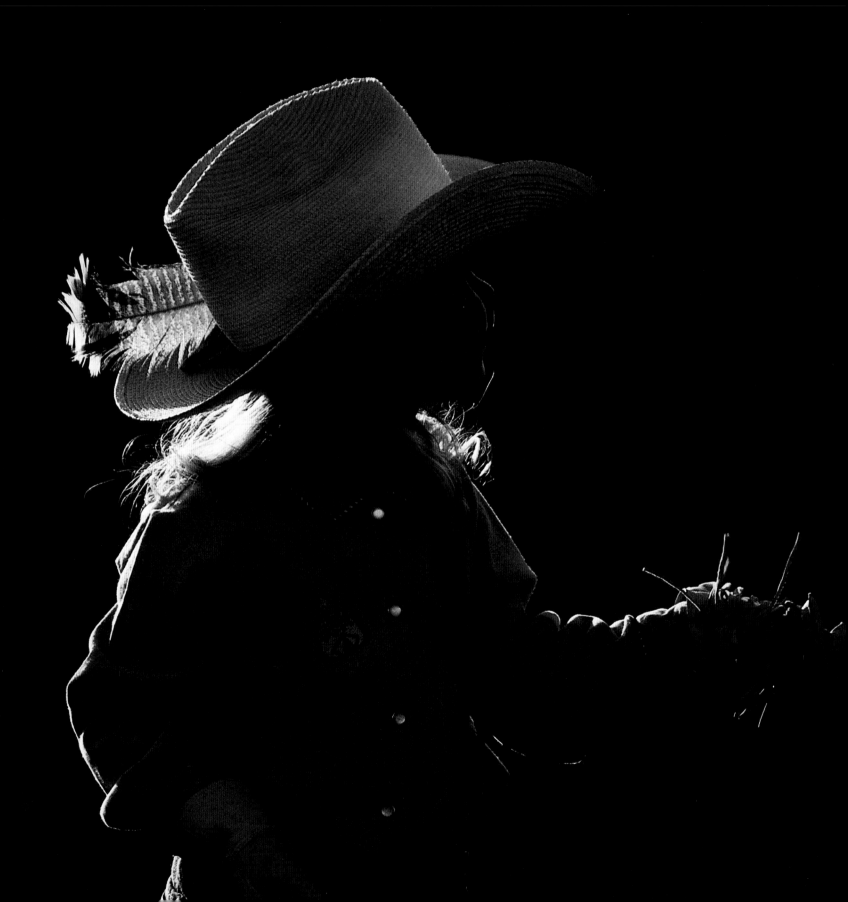

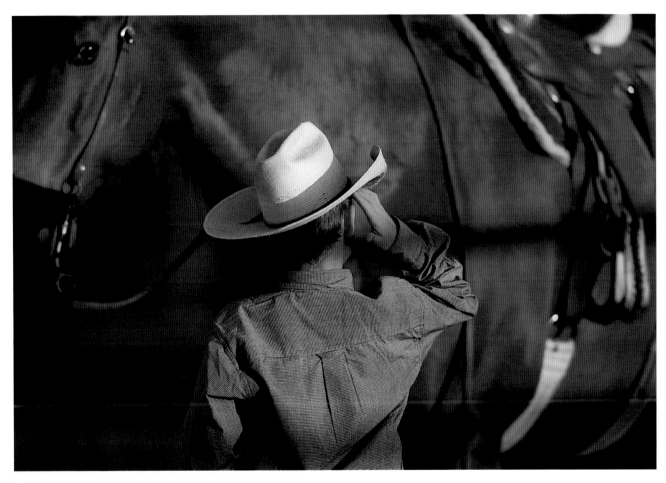

RA Brown II
R.A. Brown Ranch, Texas

Leslie Anne Saunders
Weatherford, Texas

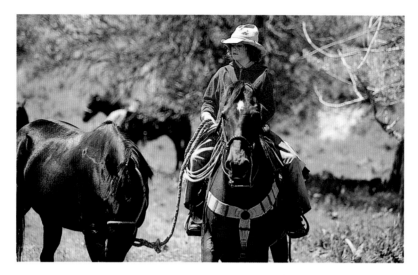

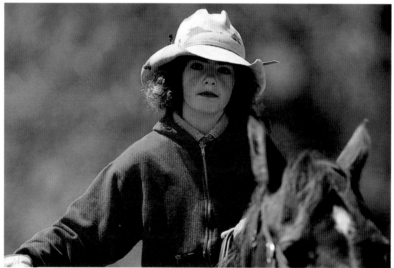

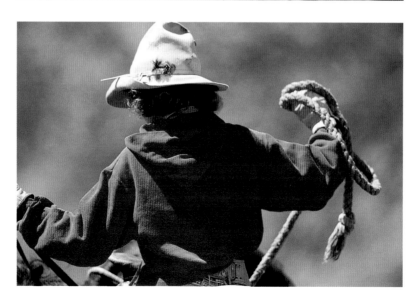

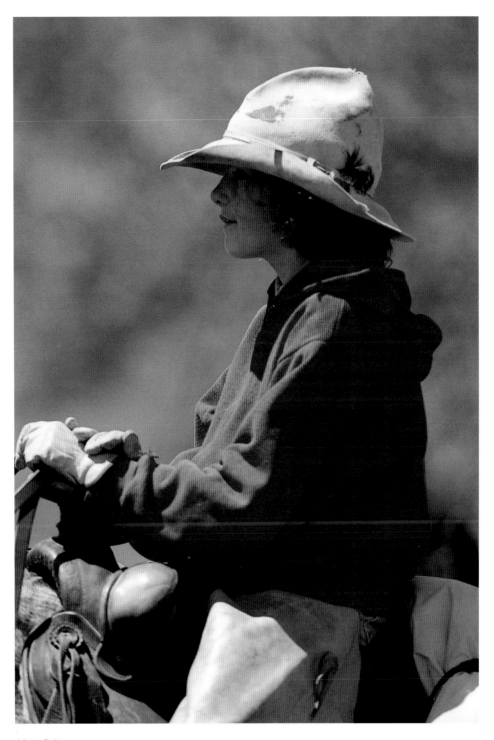

Maria Beltz
Powder River, Montana

Little girls
love their

horses.

Brandi Van Ausdale
Sherod Ranch, Oregon

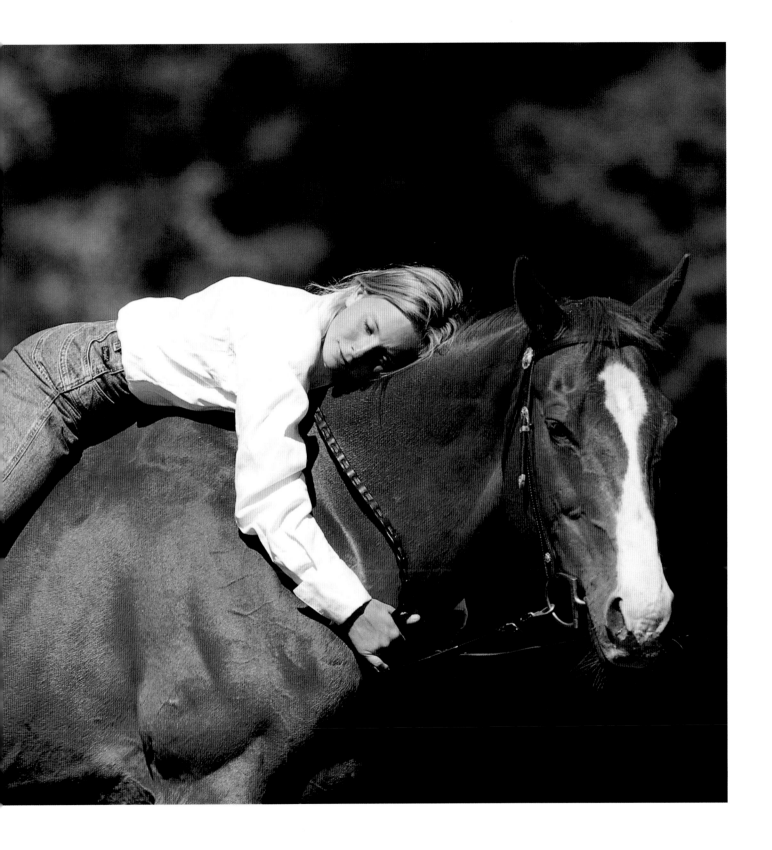

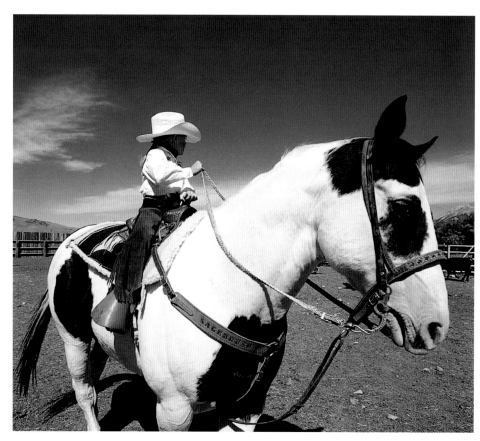

Chantelle Shields
Broken River Ranch, Idaho

Pink chaps and a
Paint horse.

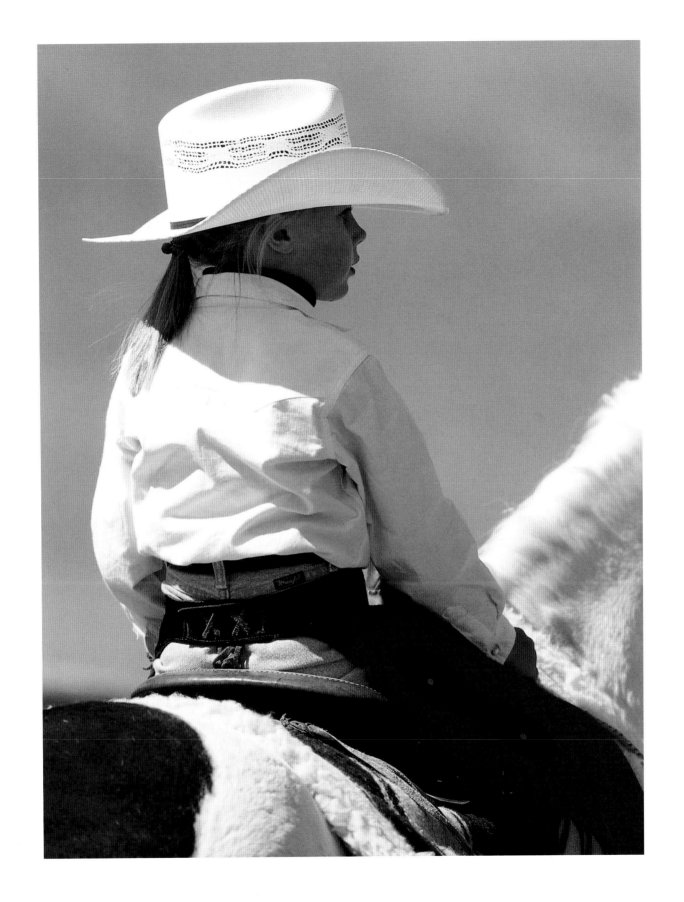

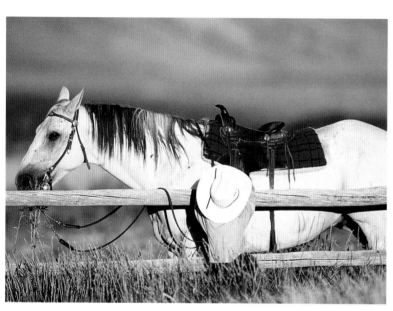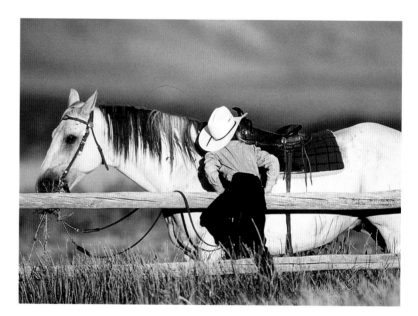

Lucy Zollinger mounts the old-fashioned way—on the fence.
Mackay, Idaho

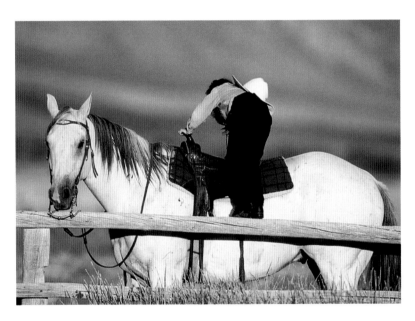
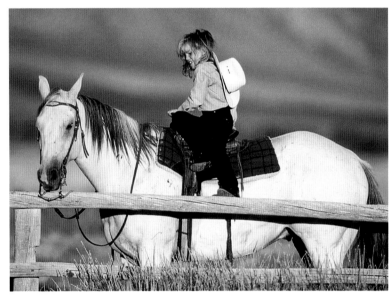

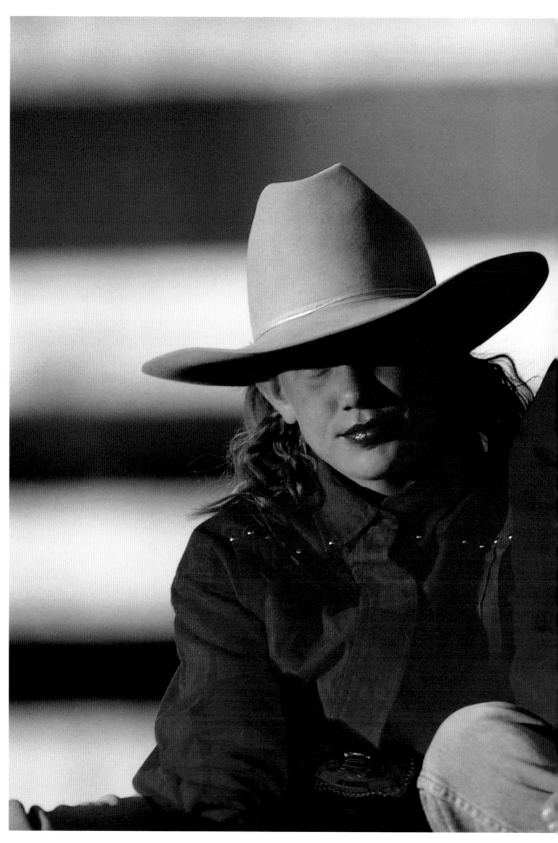

Mother

and

daughter.

Jamie and Lynn Greenfield
enjoy a quiet moment.

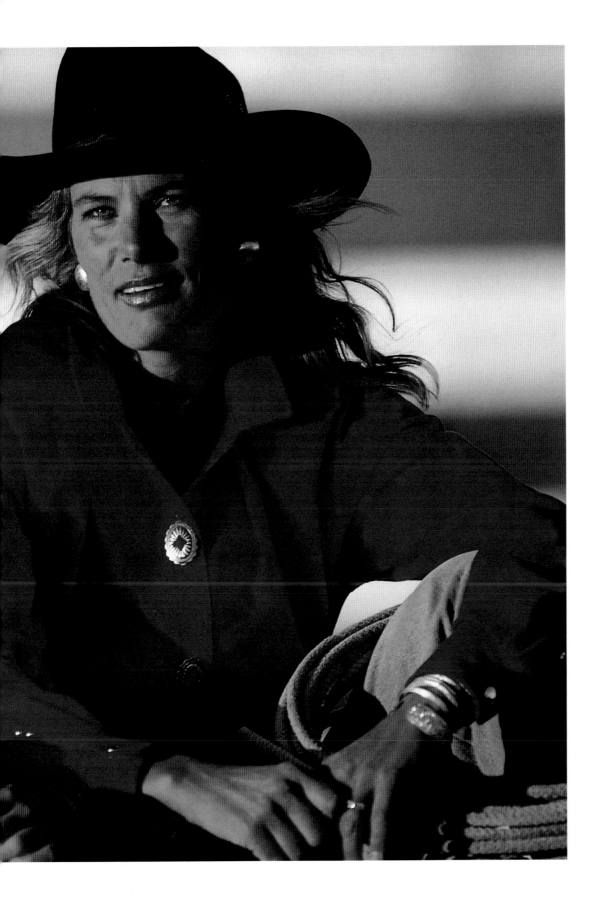

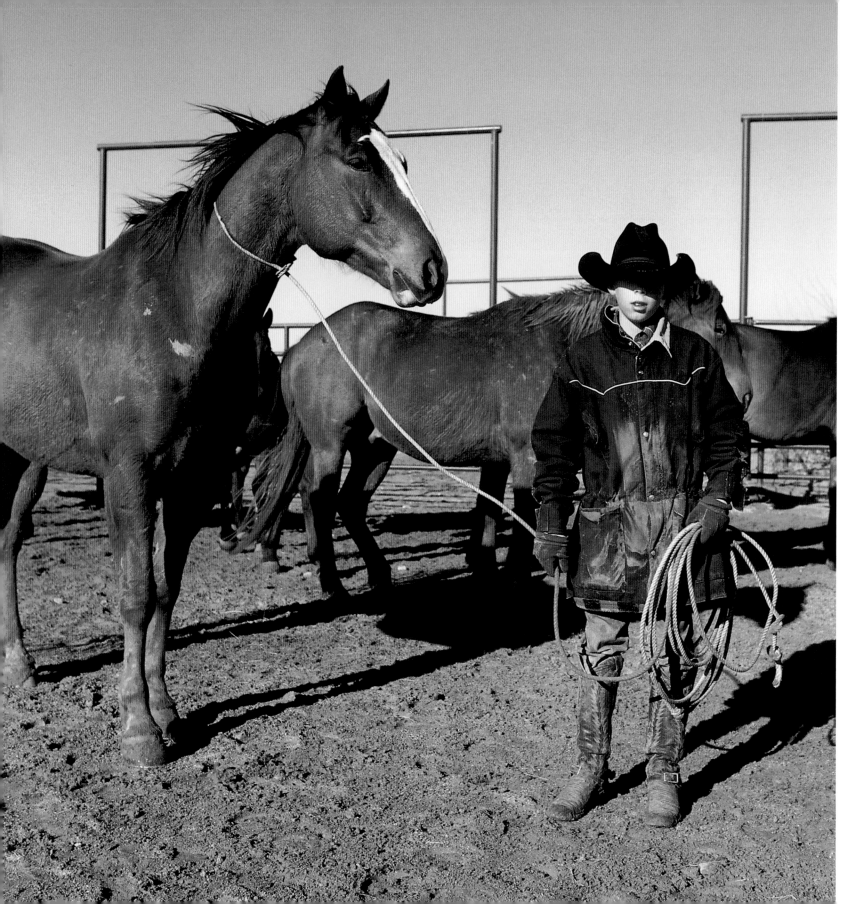

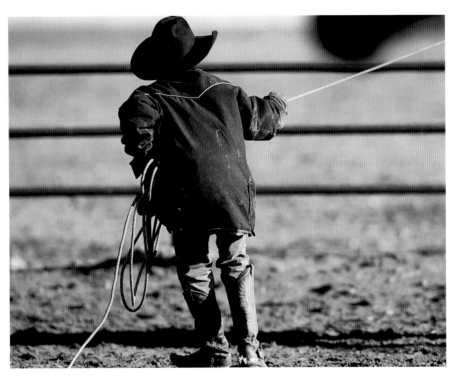

Shannon Vinson of the 6666 Ranch roped this horse and just hung
on. It pulled him on his belly all over the corral. Shannon won!

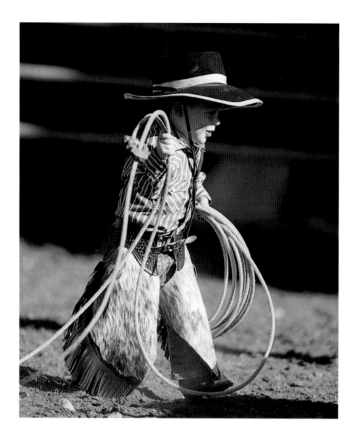
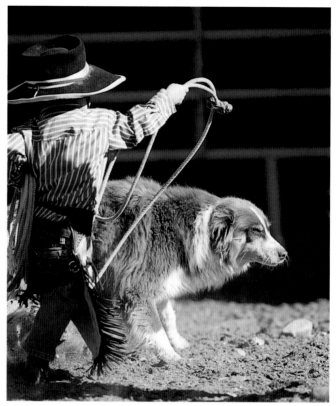
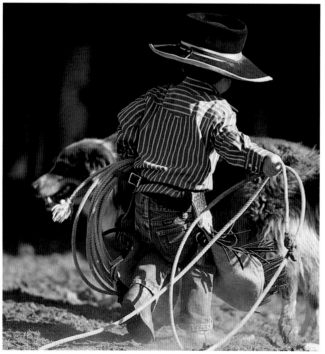
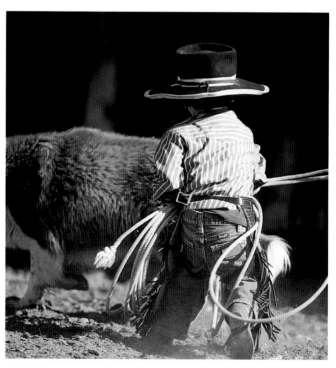

"I got 'im!"

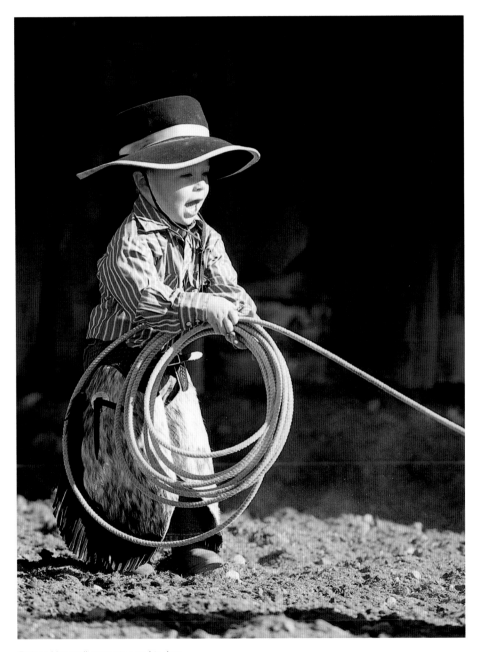

Dalton Hunewill practicing on his dog.
Hunewill Ranch, California

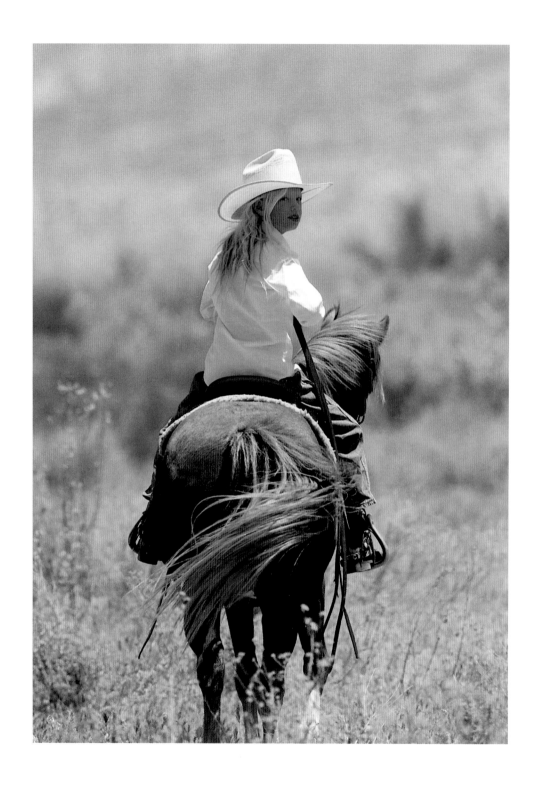

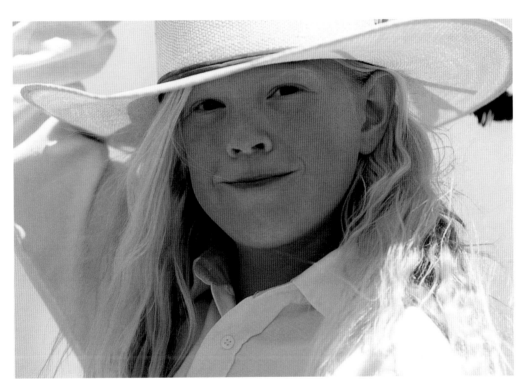

Colleen Hannum
Hannum Horse Ranch, California

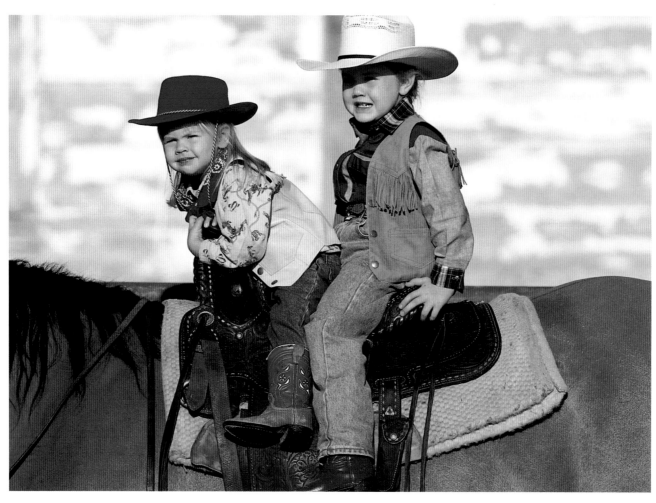

Leslie Anne and Madalynn Saunders
Weatherford, Texas

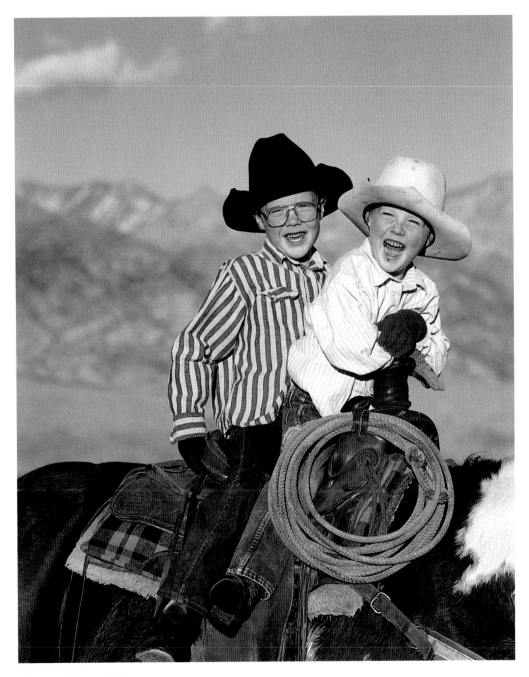

Garret and Geremy Nelson
Mackay, Idaho

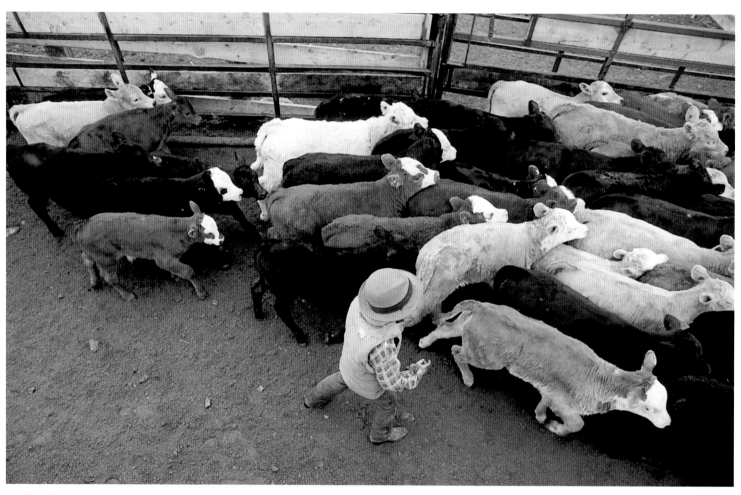

Levi Donahue
Donahue Ranch, Mackay, Idaho

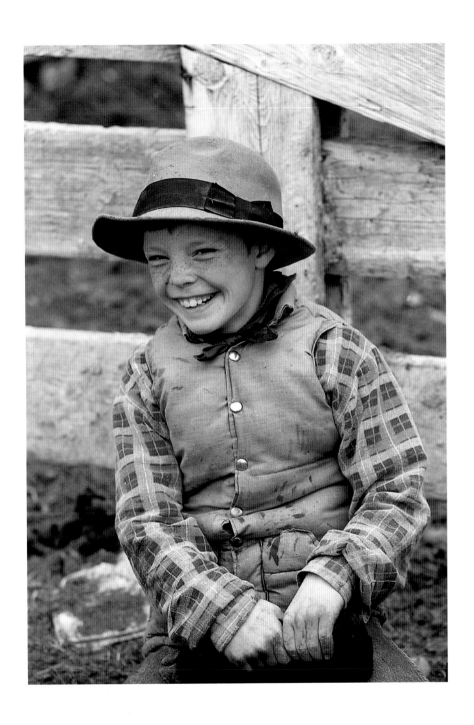

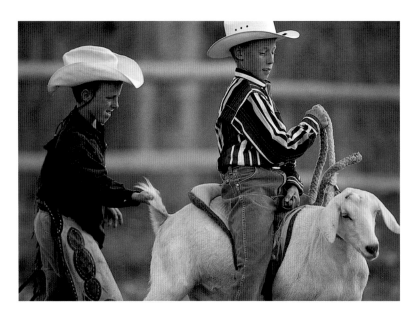

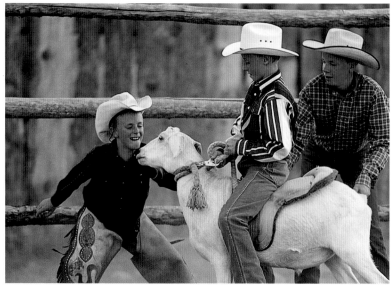

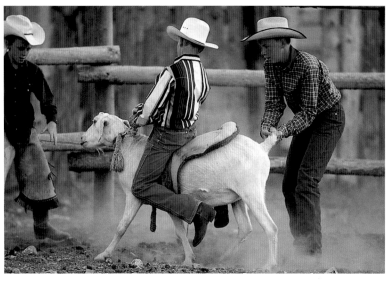

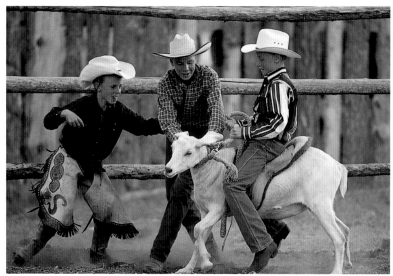

I'm not sure if Martin (the goat) likes it as much as the kids.

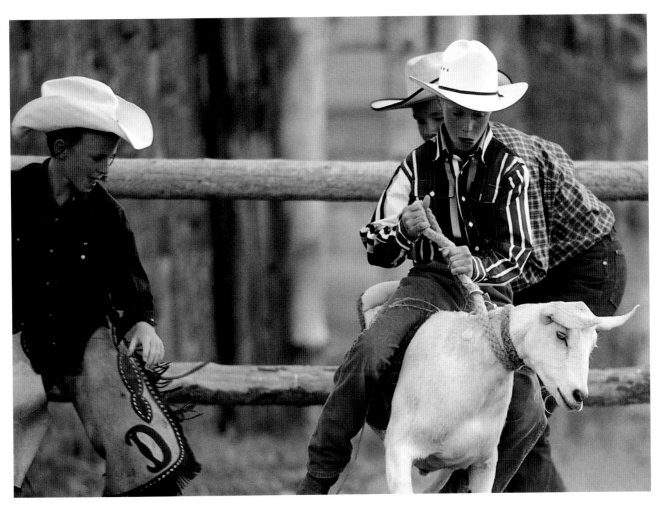

Colby Stoecklein, Matt Tilbatsen and Tyler Zollinger
Mackay, Idaho

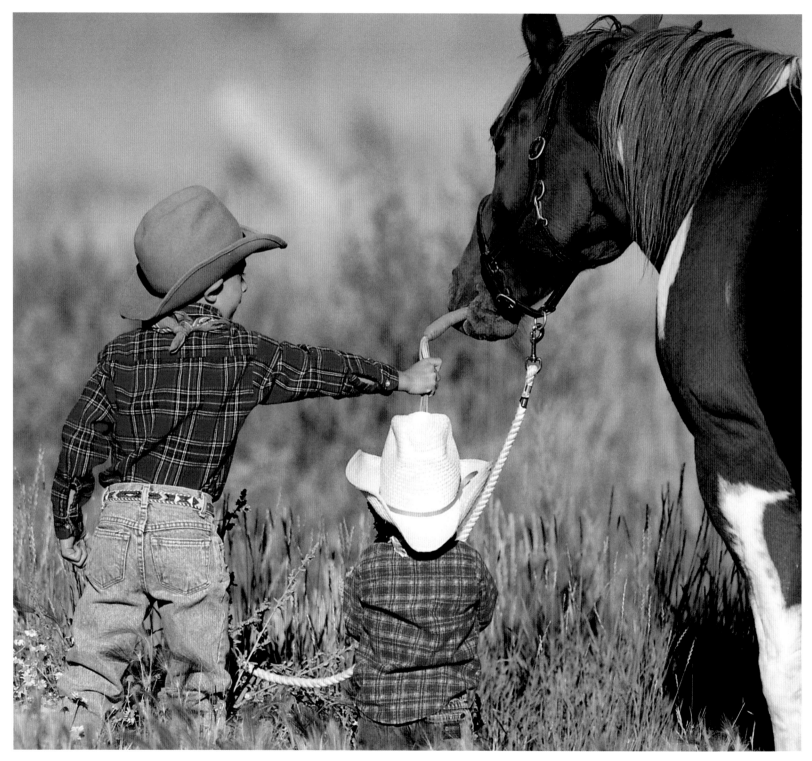

Drew and Taylor Stoecklein
Idaho

The old carrot trick.

The old apple trick.

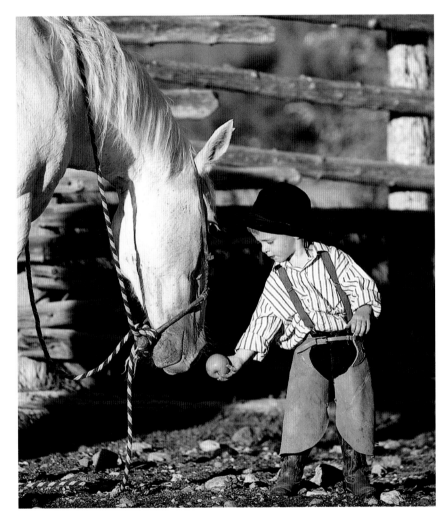

Colby Stoecklein
Idaho

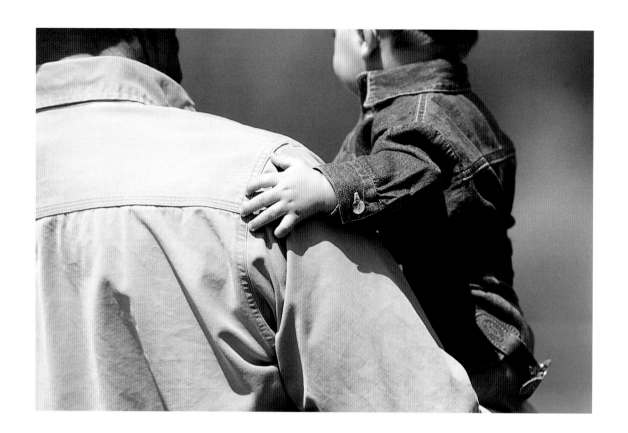

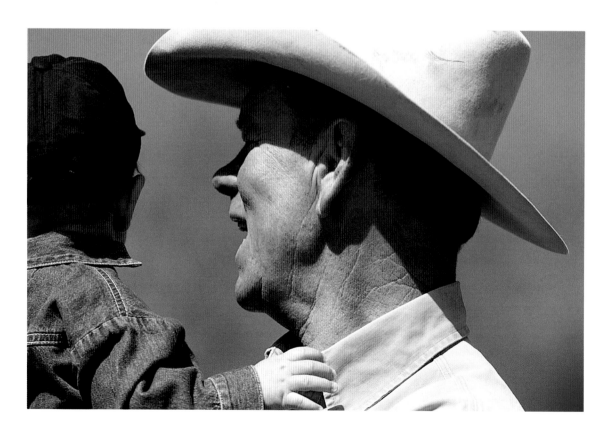

Boys love their grandpas.

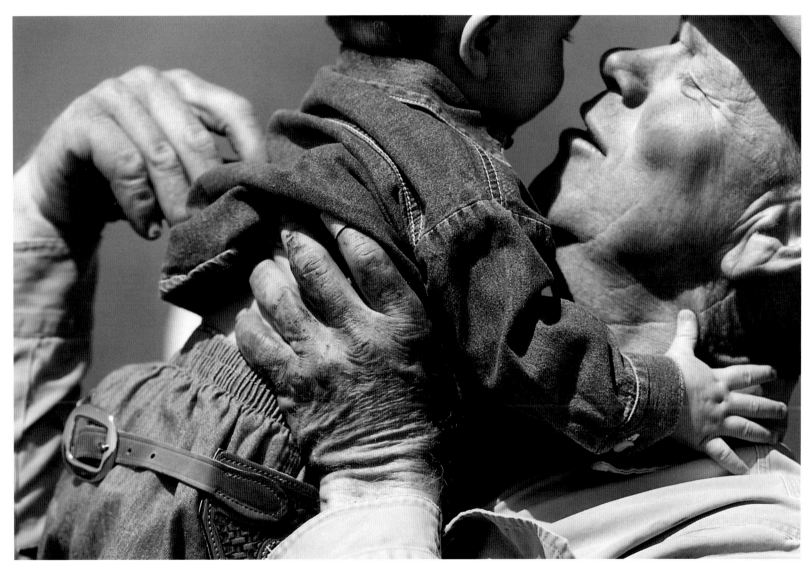

Chet Vogt and Nicolas Vogt
Elk Creek, California

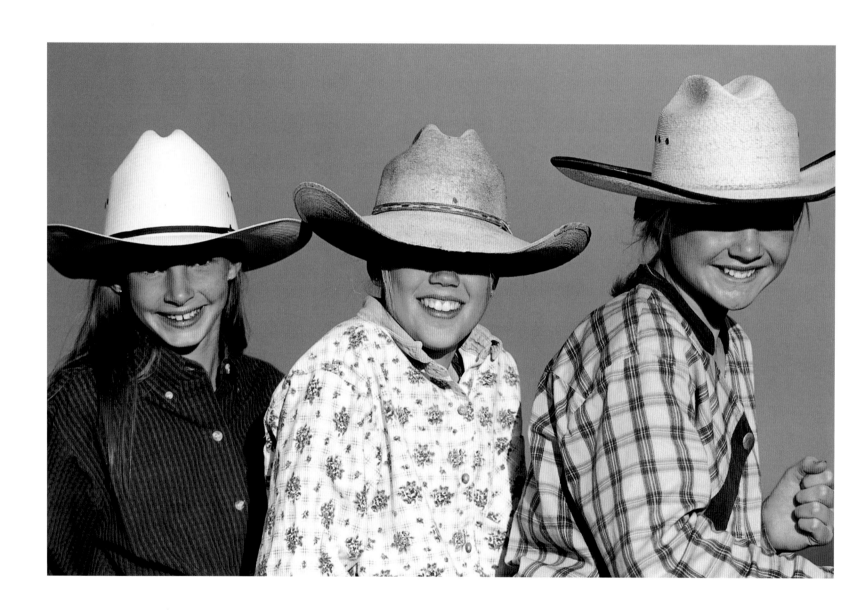

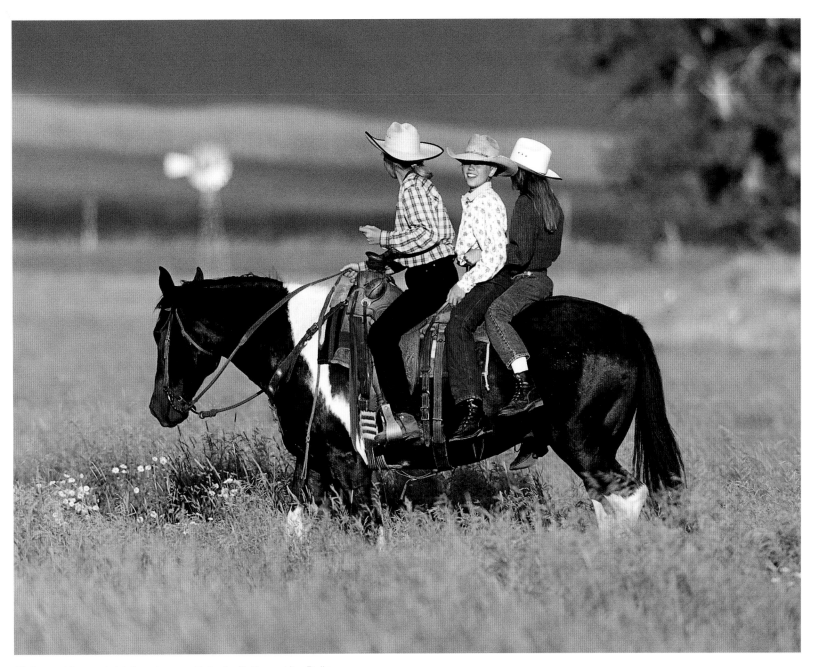

Chelsea and Bennett Leigh Rosenkrance with Jessica Zollinger riding Dolbin.
Mackay, Idaho

139

Your mind is a vast photo album

Whose pictures are not so few,

If you try, you will never forget

The sight of the child that once was you.

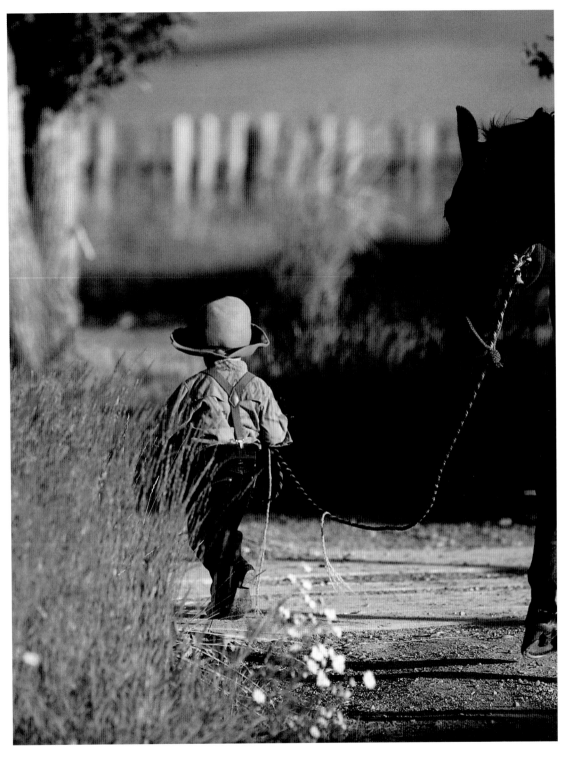

Colby Stoecklein
Bar Horseshoe Ranch, Idaho

Thanks kids,

it's been fun!

David R. Stoecklein